African Prints

a Design Book

Shirley Friedland & Leslie Piña

Schiffer Publishing Ltd®

4880 Lower Valley Road, Atglen, PA 19310 USA

Book Design: Leslie Piña
Layout by Bonnie M. Hensley
Type set in Windsor BT bold/Korrina BT

ISBN: 0-7643-0694-4
Printed in China

Published by Schiffer Publishing Ltd.
4880 Lower Valley Road
Atglen, PA 19310
Phone: (610) 593-1777; Fax: (610) 593-2002
E-mail: Schifferbk@aol.com

In Europe, Schiffer books are distributed by Bushwood Books
6 Marksbury Rd. Kew Gardens
Surrey TW9 4JF England
Phone: 44 (0)181 392-8585; Fax: 44 (0)181 392-9876
E-mail: Bushwd@aol.com

Please write for a free catalog. This book may be purchased from the publisher.
Please include $3.95 for shipping. Please try your bookstore first. We are interested in
hearing from authors with book ideas on related subjects.

dedicated to the designers of African prints

Acknowledgments

In addition to the author's collection of fabric, examples were borrowed from Beverlee Rosenbluth; Dorothy Brown of International Fabric Collection, 3445 West Lake Rd., Erie, PA 16505, email: intfab@aol.com, web site: http//www.intfab.com; Jacqueline A. Benton of Fine Linen and Purple, Box 360099, Decatur, GA 30036; and Minnesota Fabrics. Our thanks also to Nancy and Peter Schiffer for having such varied interests and to the staff at Schiffer Publishing.

Contents

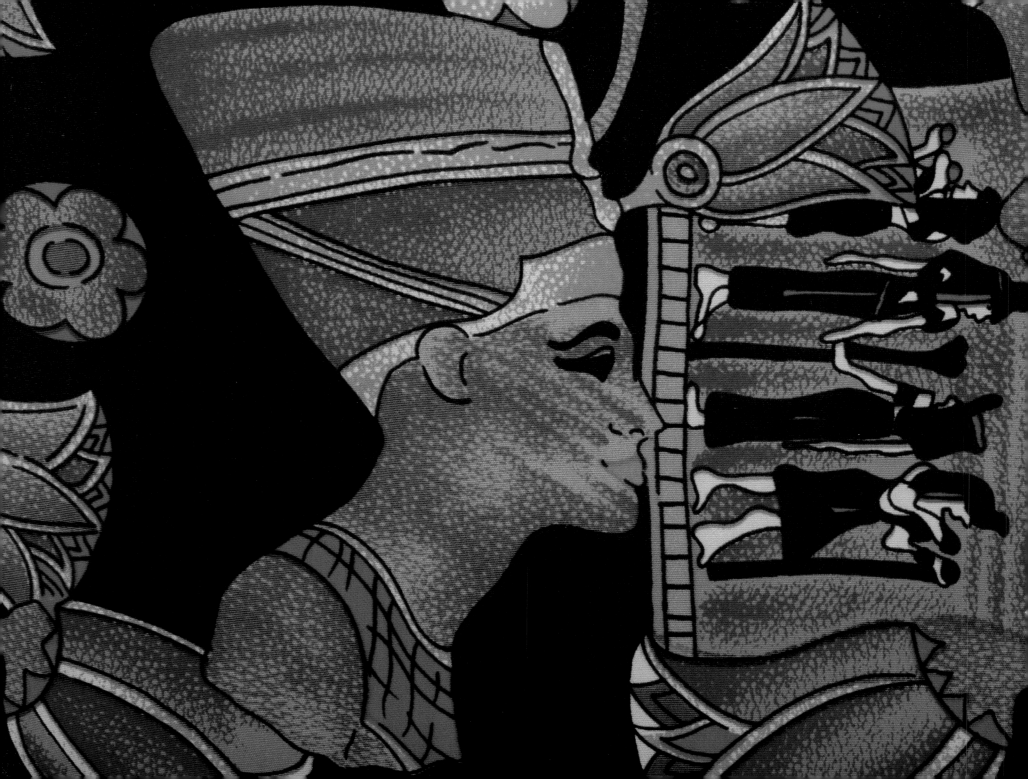

Introduction

Fabric design is one of the most visual and accessible bridges to cultures other than one's own. Personal adornment and interior decoration, such as rugs, have always fascinated foreign visitors. Traditional colors, patterns, and techniques characterize local tribal and village societies and even entire countries. Examples of native textile arts have served as emissaries, because of their universal appeal. They also have been among the easiest material goods to export – textiles can be made into any size or shape of unbreakable package. With reasonable care, they are durable – some lasting for centuries. Besides ease of transport, they can be readily copied or adapted. The evolution of Modern Art would have taken a different turn if not for a European fascination with African design.

Africa, the richly varied and mysterious continent, has always intrigued Europeans and Americans, though except for colonists, few have actually seen it. Visual impressions have been regularly provided by television documentaries and nature programs with spectacular scenery and photography. It is precisely this wild and beautiful environment that has inspired the equally wild and beautiful textiles created by people from various and varying cultural traditions. These designs have a certain identifiable look, even to those unfamiliar with the cultures that produced them or with their symbolic meanings. Most are bold, abstract or geometric, and in bright clear colors or dramatic high-contrast neutrals. A preponderance of grid-like formats on modern printed adaptations is due to the originals being woven on a loom with perpendicular weft and warp. Though not hand woven, the color and pattern is reproduced on the modern fabric by commercial roller printing and wax-printing methods.

The following pictorial survey is arranged visually, regardless of designer, material, technique, or origin. Focus is on design, particularly color and pattern. The fabric shown here is contemporary. Most is made of cotton; the rest is either rayon, wool, a blend, or synthetic, and it may include metallic thread or surface embellishment. Some examples are printed adaptations

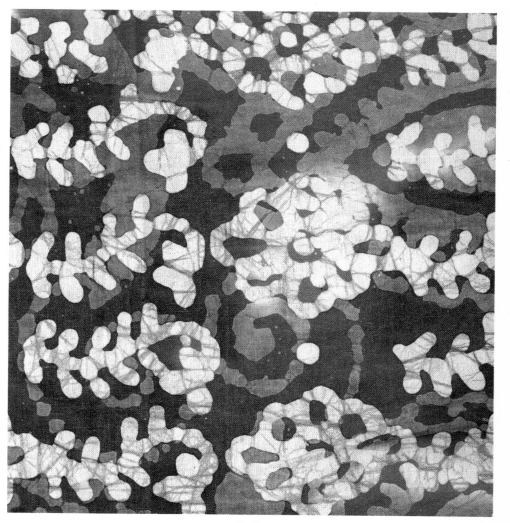

Batik

of traditional woven textiles, because the pattern and color and their effect are the essential qualities. Though traditional handmade textiles are still produced in Africa, the modern printed fabrics are the subject of this book. They are African designs made in Africa, though some may actually be manufactured elsewhere. These commercially-produced fabrics are used domestically or exported to Europe and the United States where many non-Africans can also wear the exciting colors and designs. All of the fabrics shown in the following pages are available from stores in the United States. We hope that these pictures can also serve as a reference and as inspiration to artists, designers, and anyone involved with fashion and fabric.

This volume includes examples of complex geometric and abstract patterns, florals, pictorials, and animal and figural themes. A companion volume, entitled *African Fabric Designs,* shows simple, bold, two and three-color designs, stripes, stripe formats, and overall geometric patterns.

There are excellent books containing historical, cultural, and technical information and pictures of traditional textiles and their methods of production. A selected bibliography has been provided to help locate some of these references. These two volumes are strictly visual – our goal is to stimulate the imagination and provide pleasure in seeing the wonderful designs. A colleague at Ursuline College, Sr. Charlotte Trenkamp, says, "the pages are like ice cream, because they make you want to lick them." We hope that you will enjoy them too.

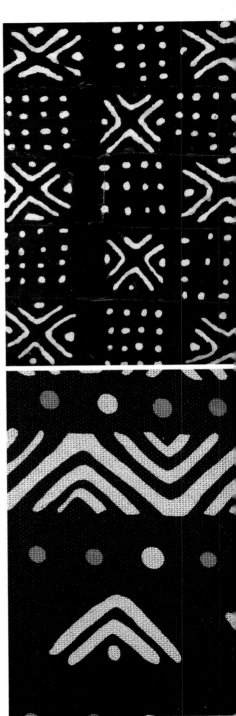

Bogolanfini ("mud cloth") *courtesy Fine Linen and Purple*

Printed fabric with design effect of mud cloth

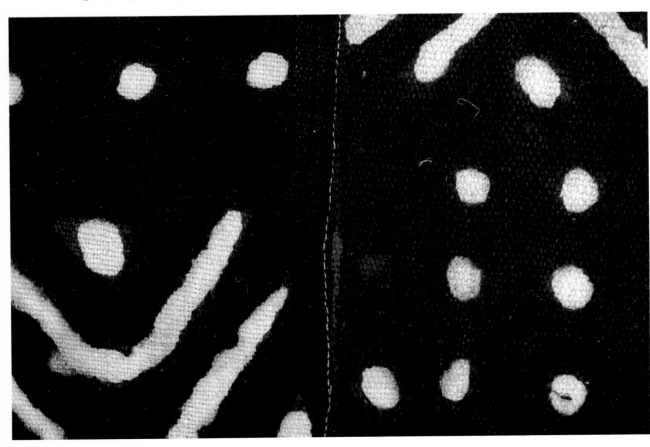

Mud cloth detail

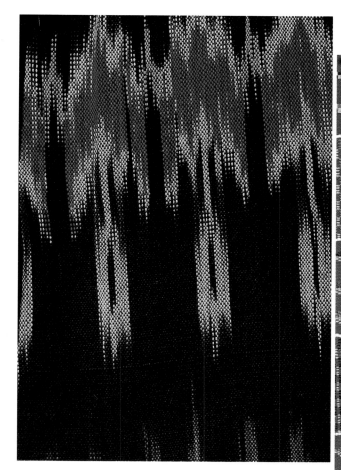

Ikat *courtesy International Fabric Collection*

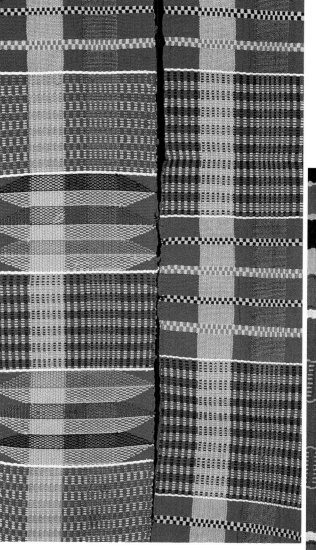

Kente cloth *courtesy Fine Linen and Purple*

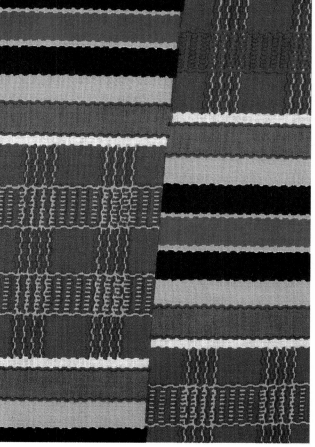

Printed fabric with design effect of kente cloth

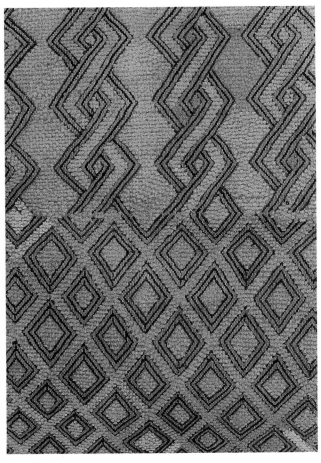

Raffia

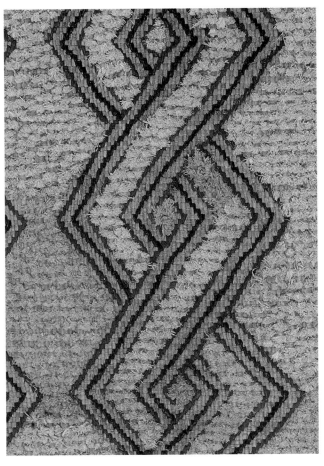

Detail

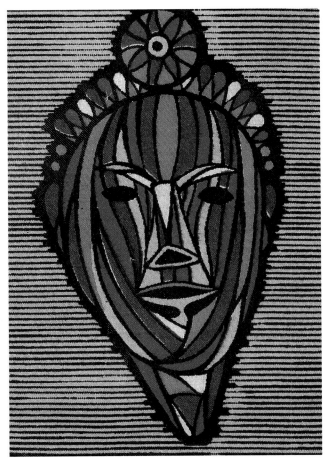

Roller printed

Opposite page:

Left: Tie-dyed

Right: Wax-printed

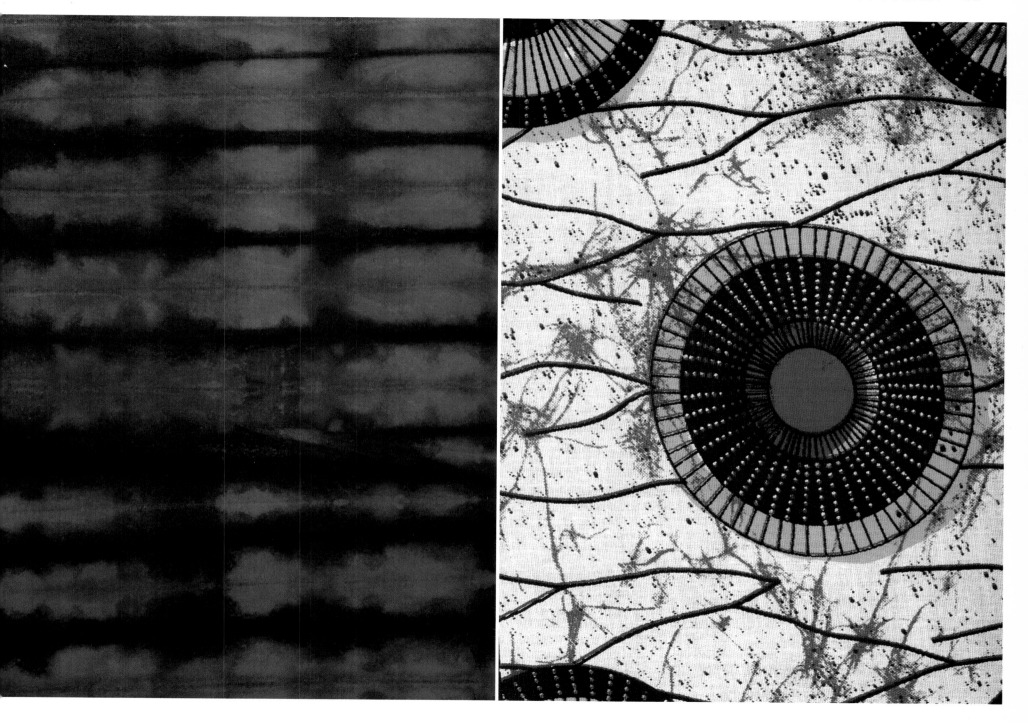

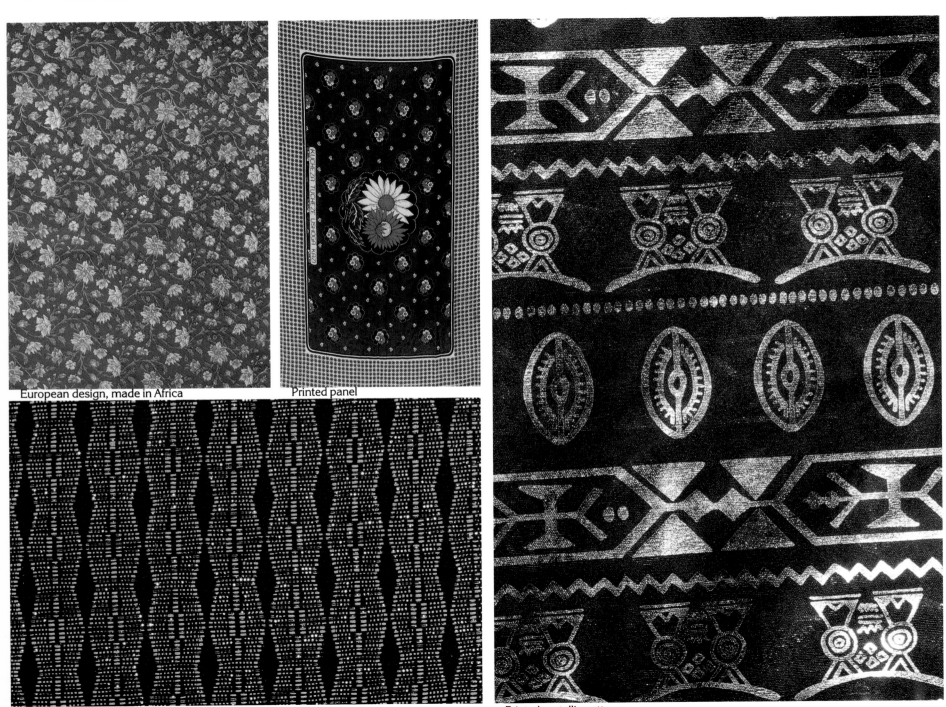

European design, made in Africa

Printed panel

Machine-woven fabric incorporating metallic threads

Printed metallic pattern

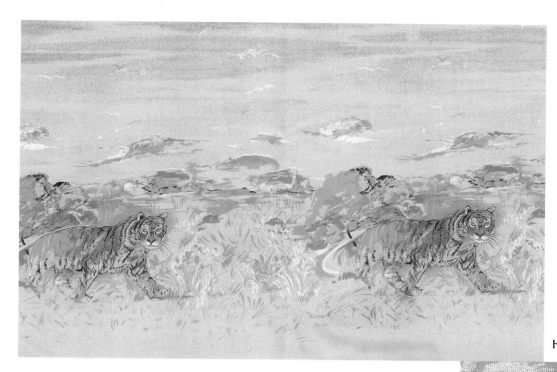

Hand-painted design

Detail

Opposite page:

Top left: European design, made in Africa

Top center: Printed panel

Bottom left: Machine-woven fabric incorporating metallic threads

Right: Printed metallic pattern

Abstract & Geometric Prints

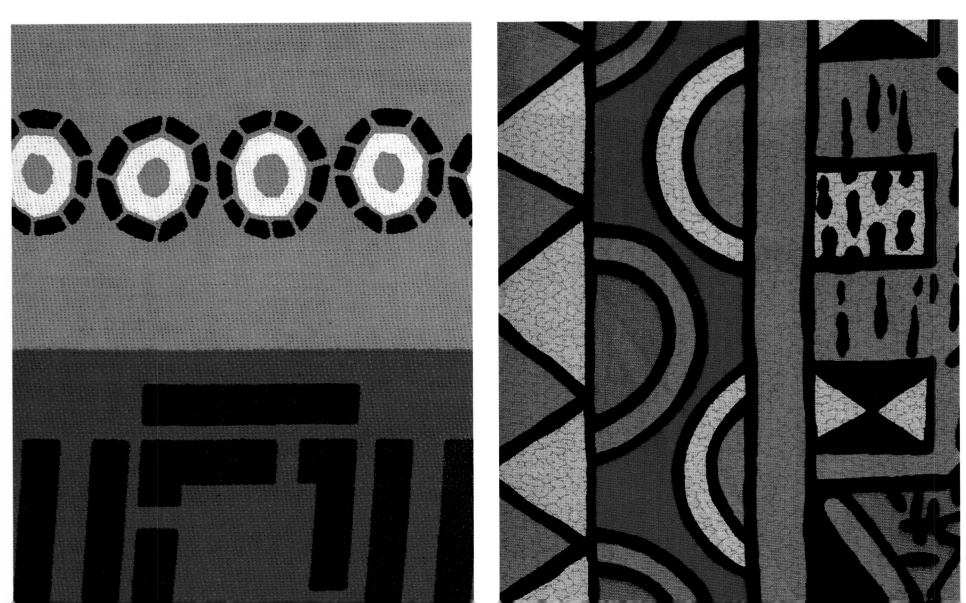

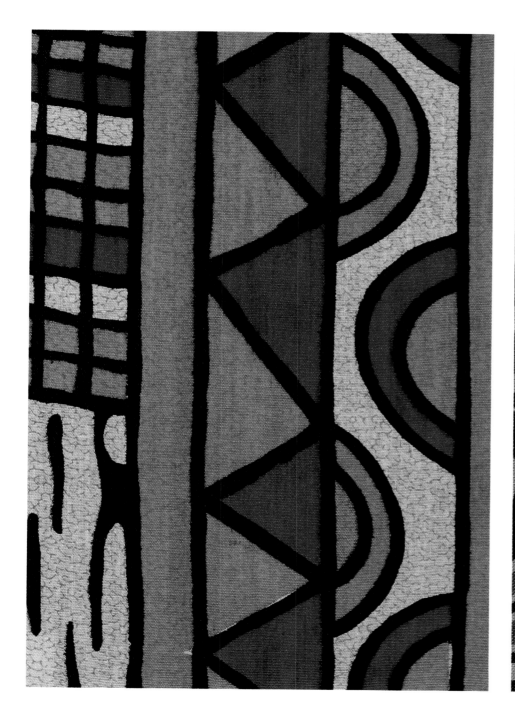

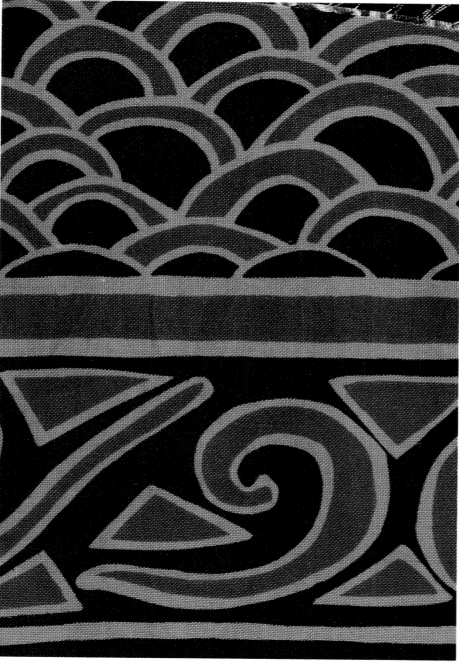

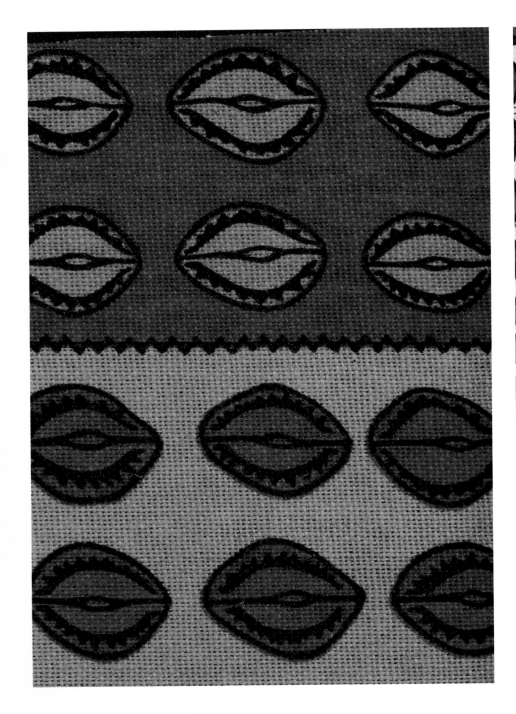
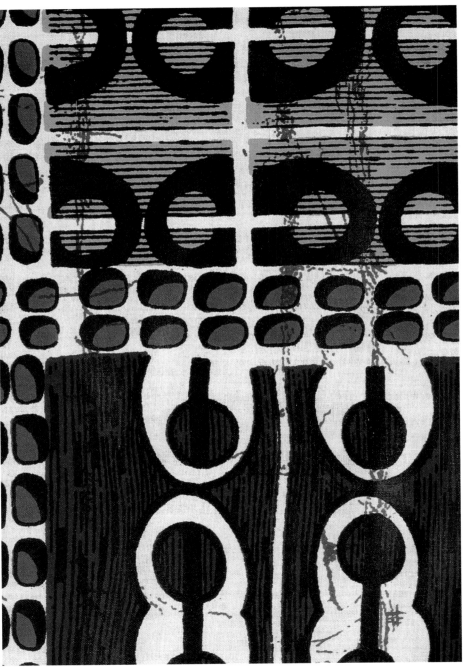

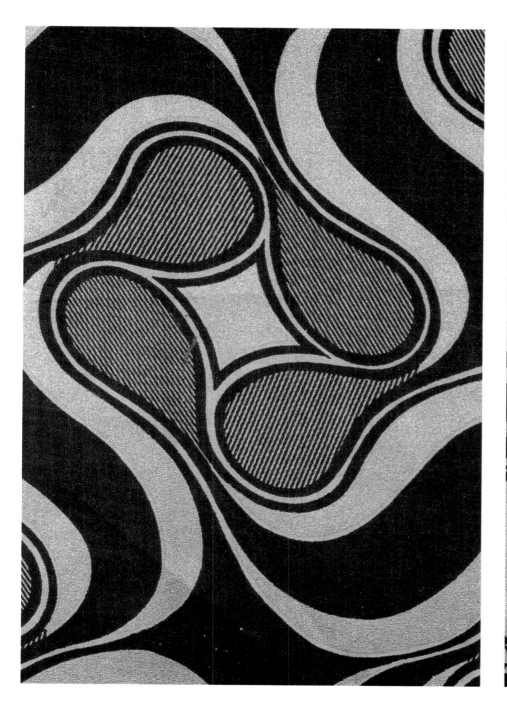

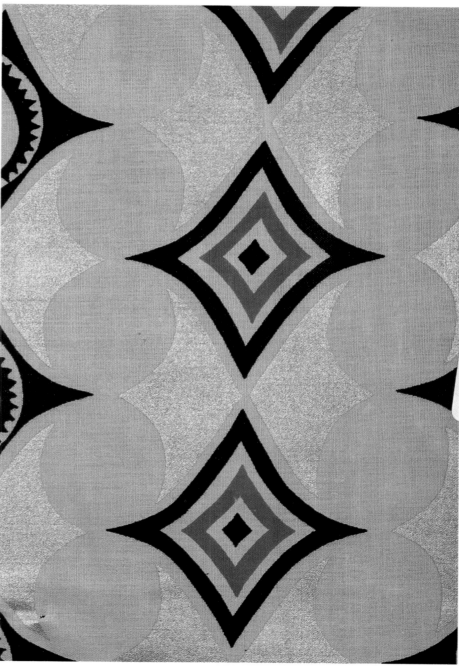

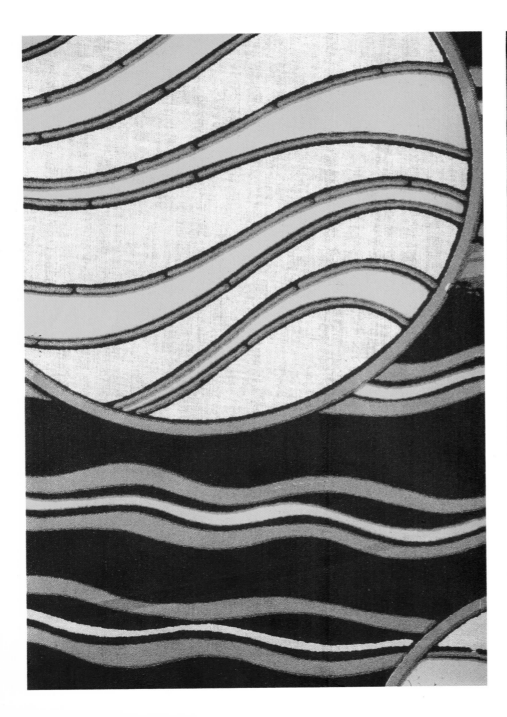

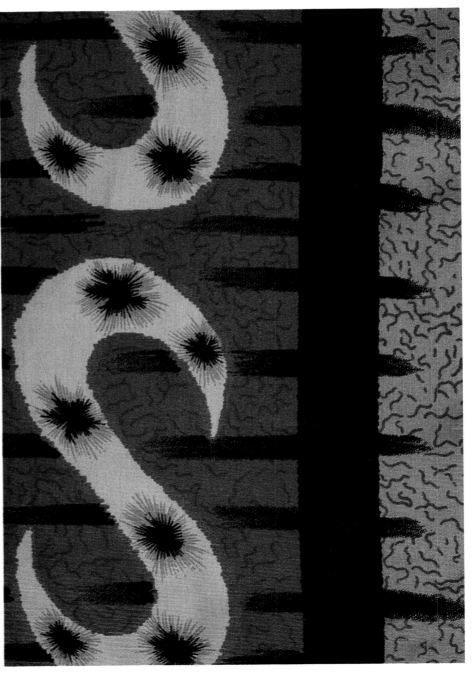

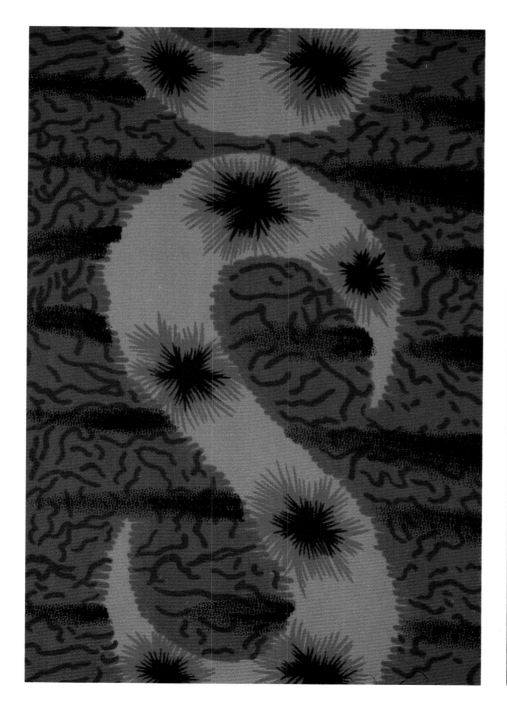

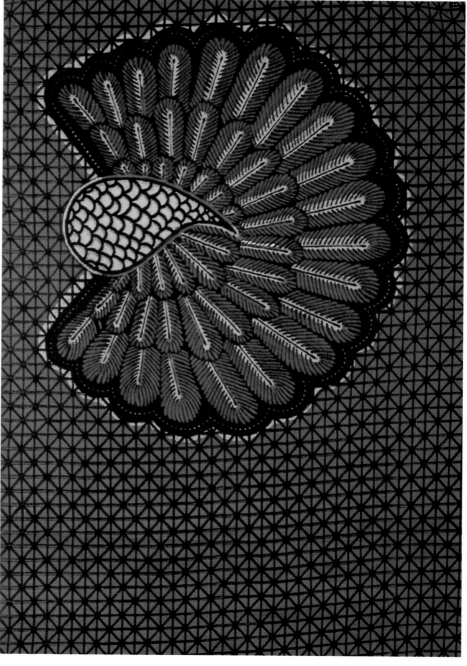

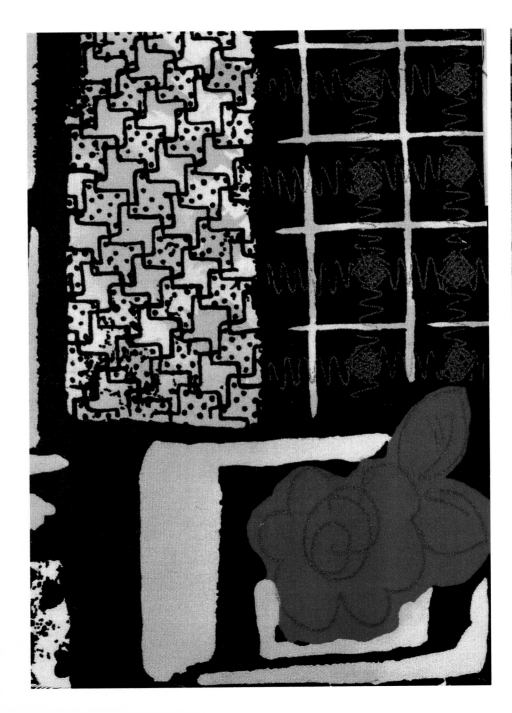

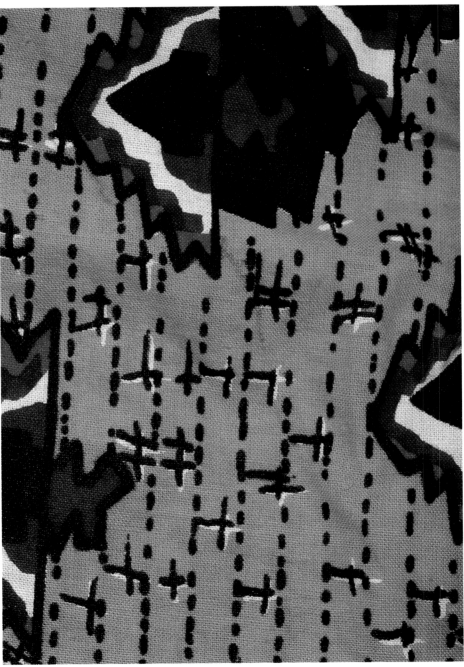

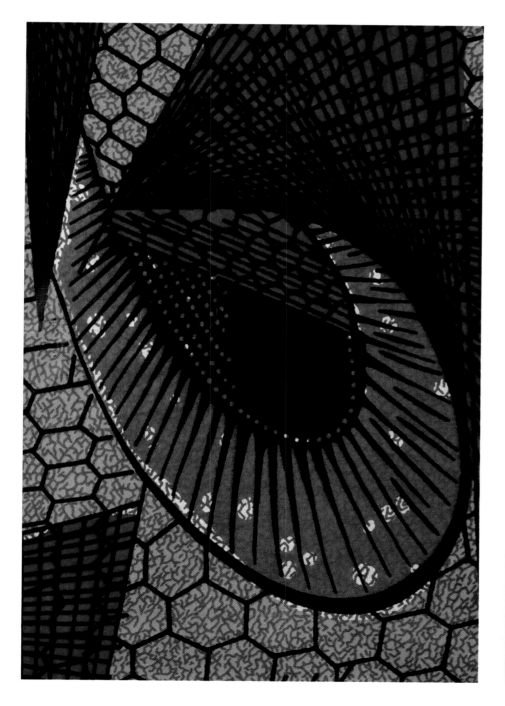

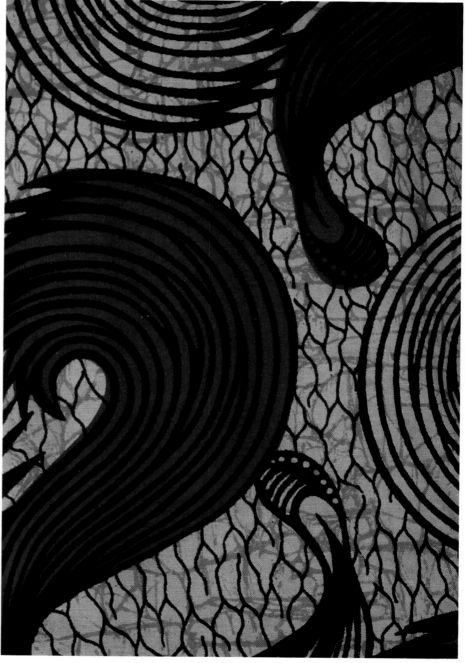

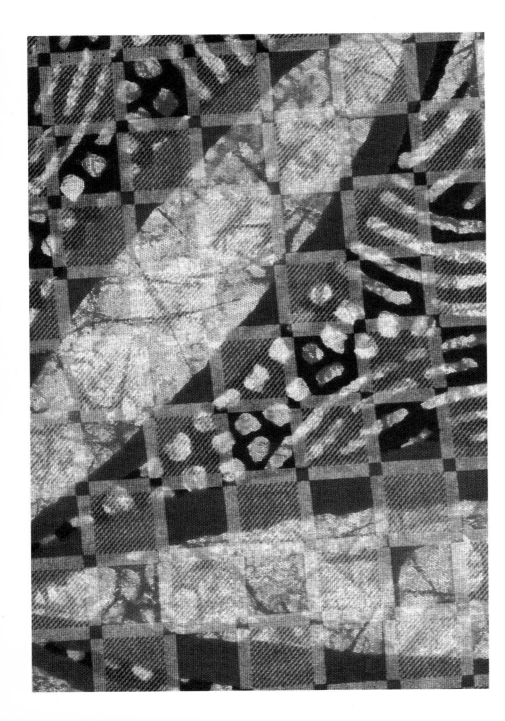

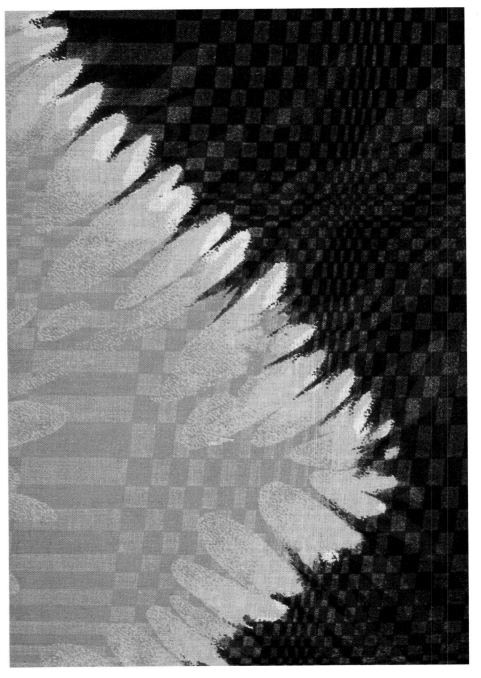

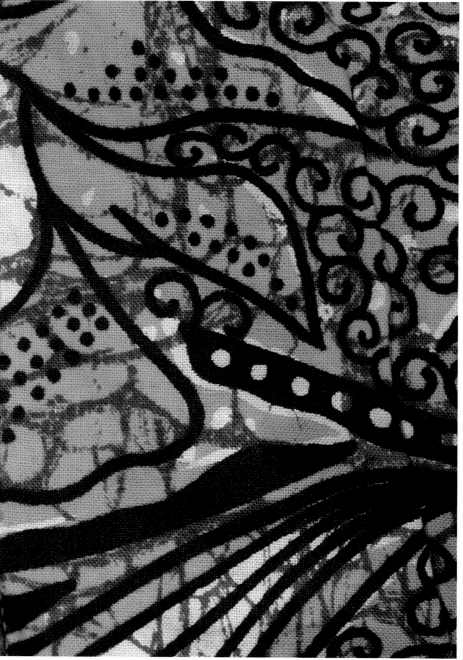

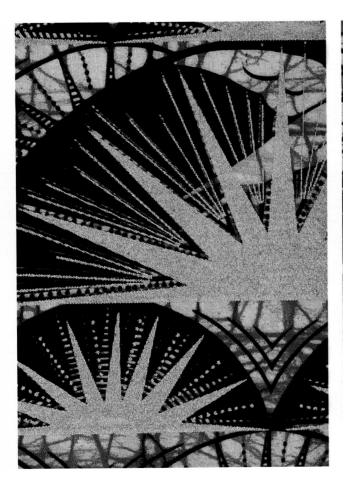
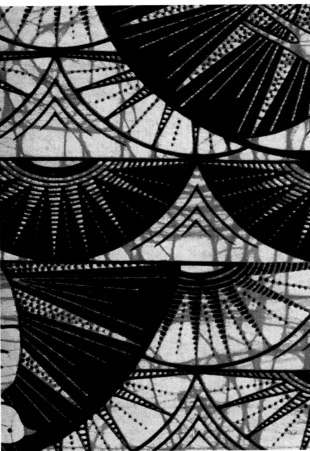
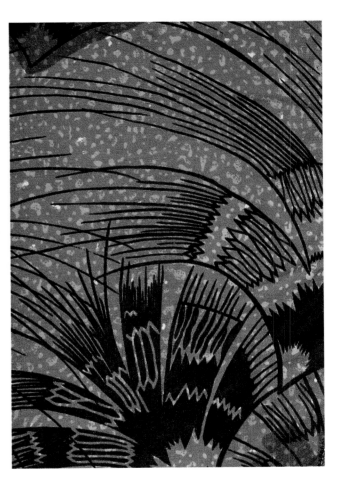

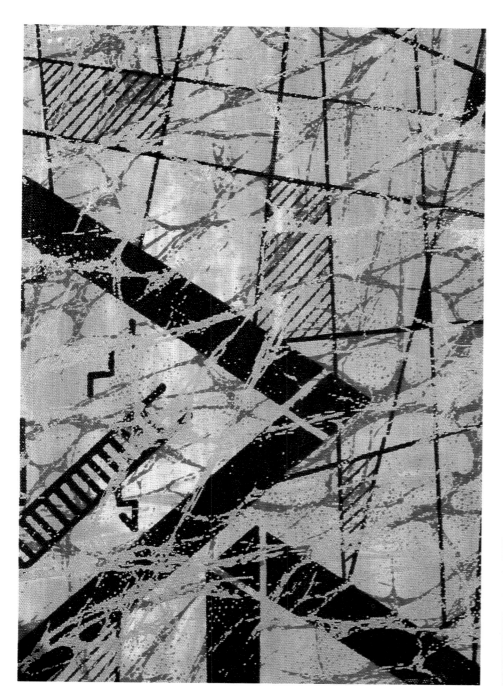

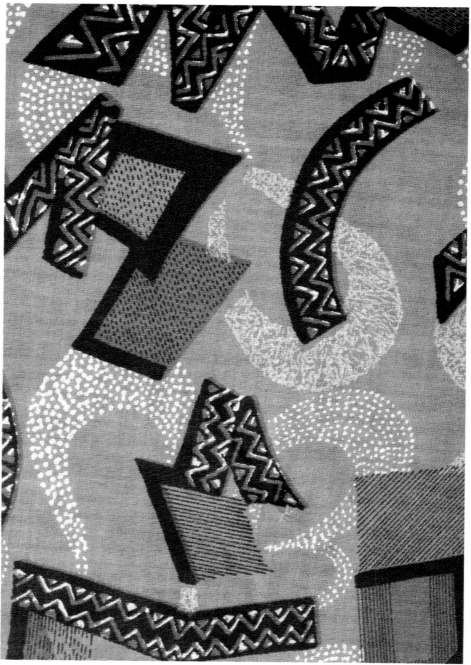

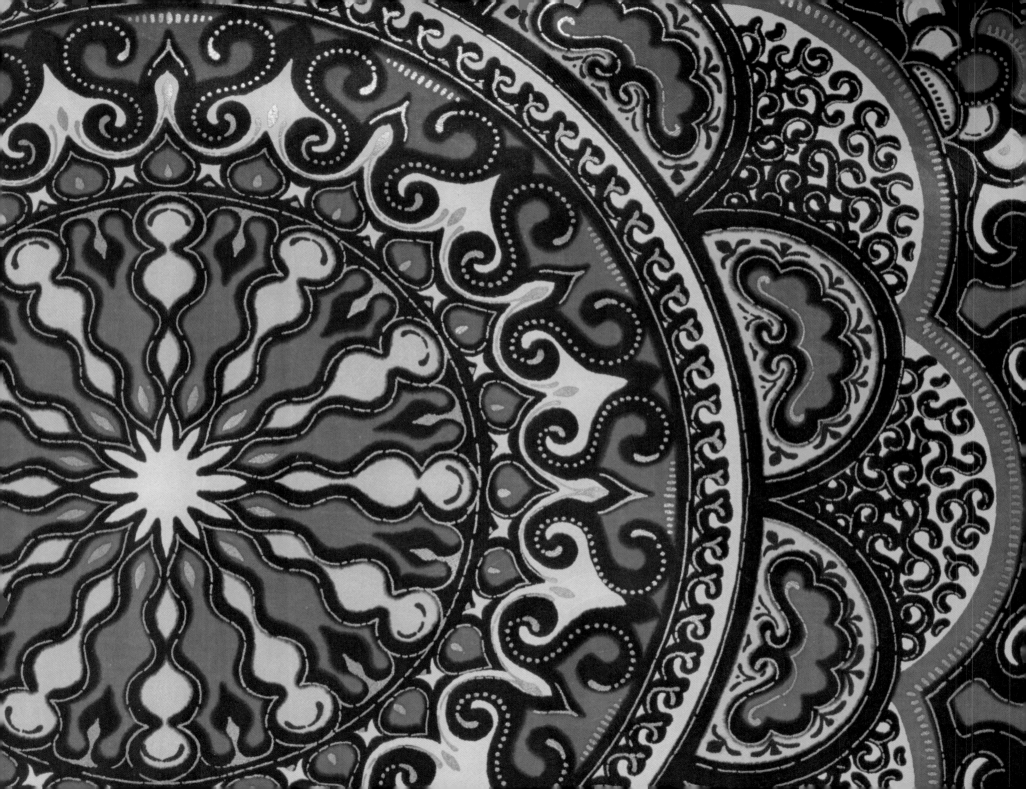

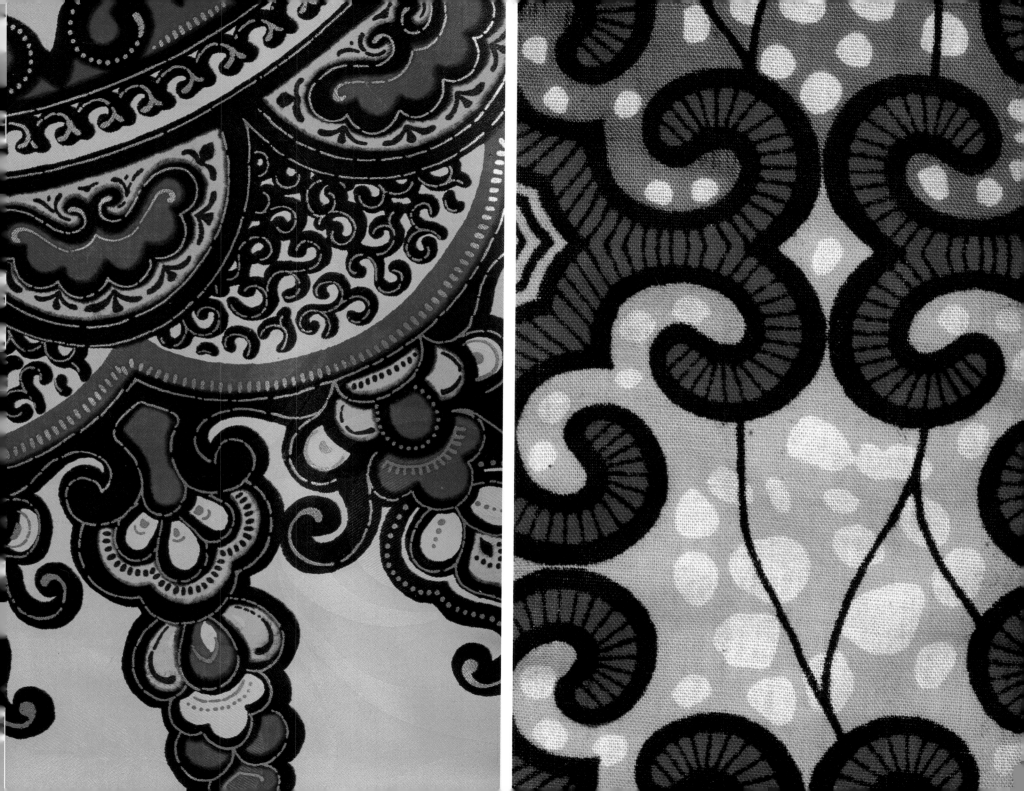

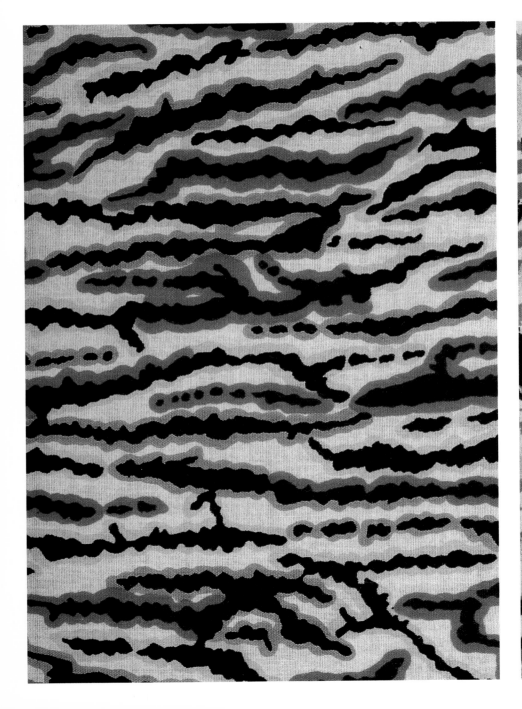

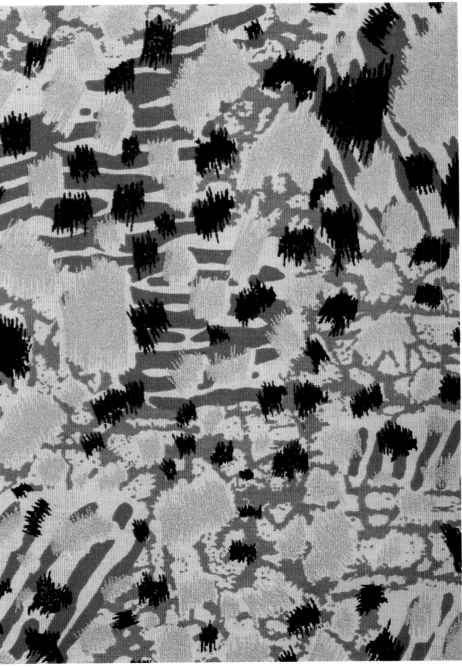

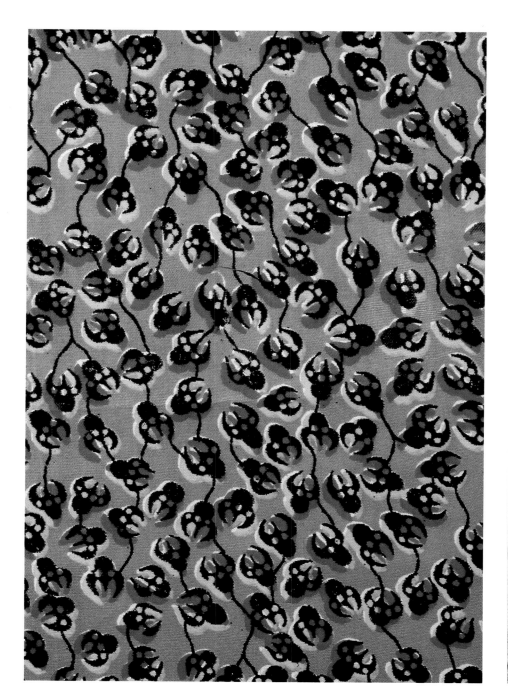

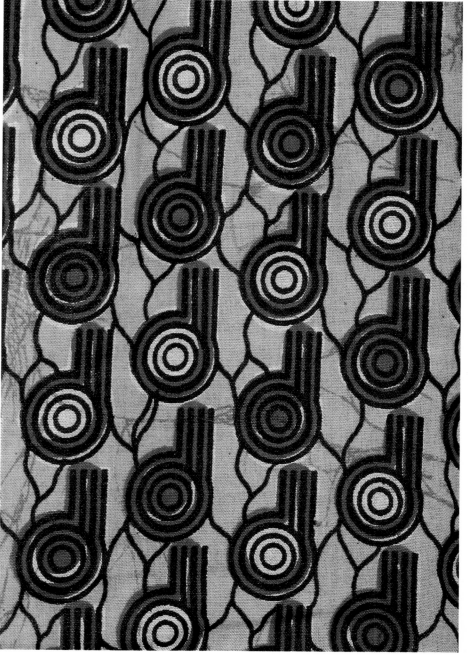

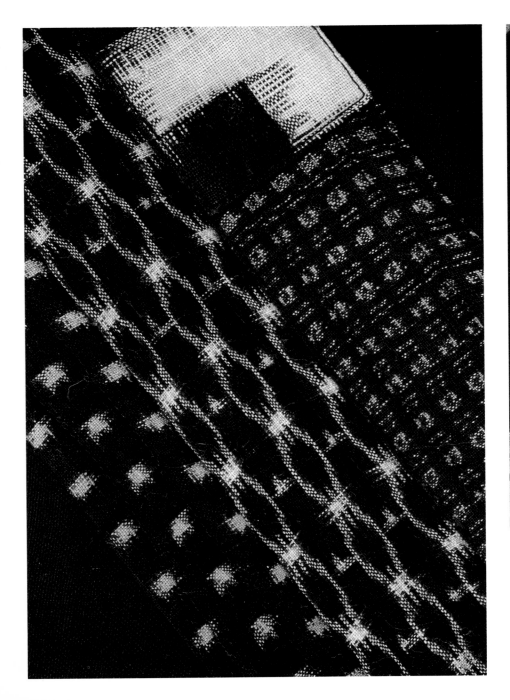

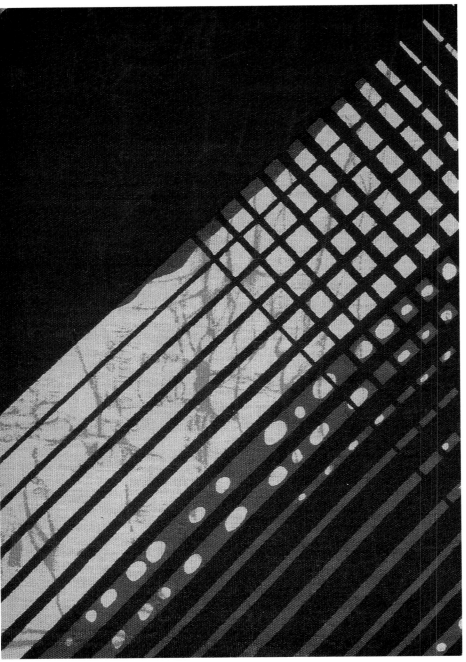

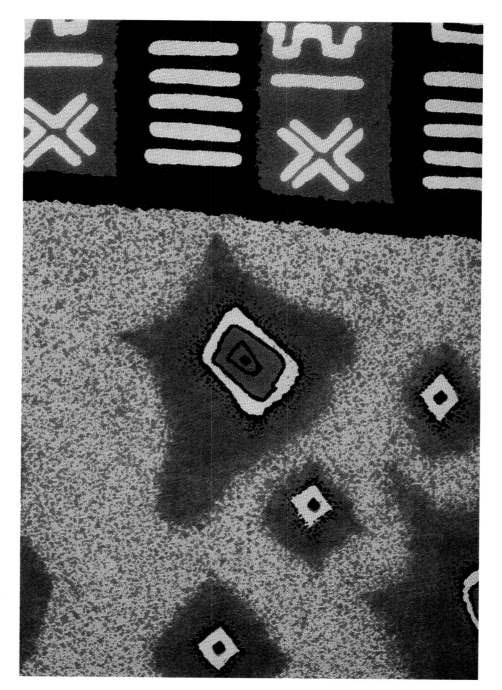

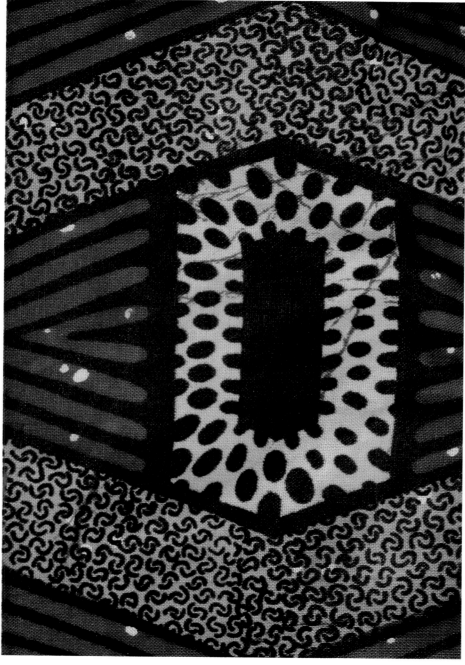

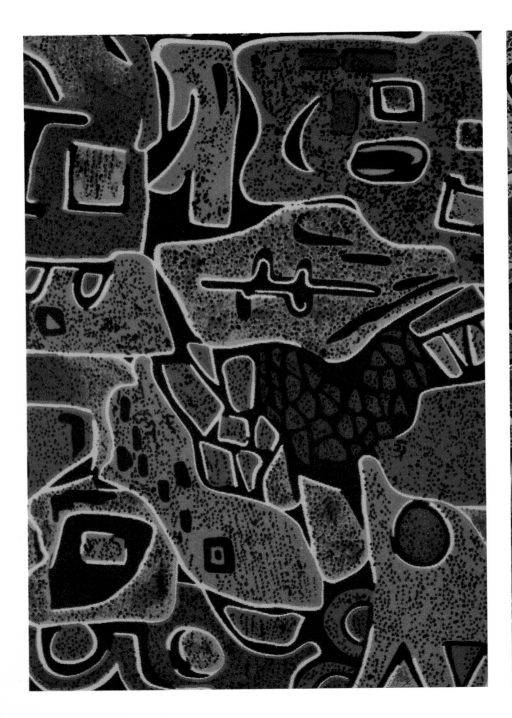

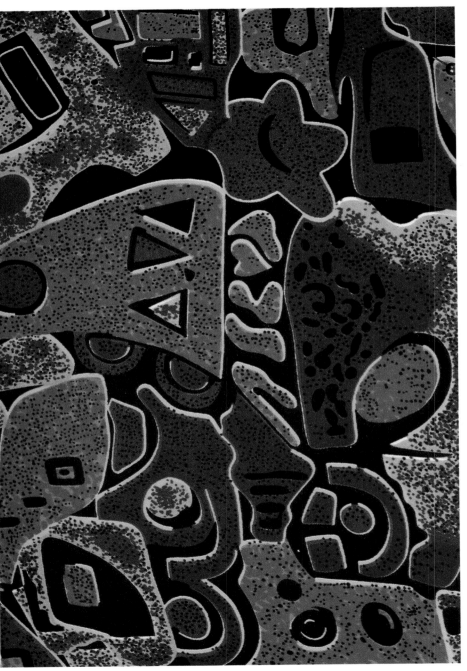

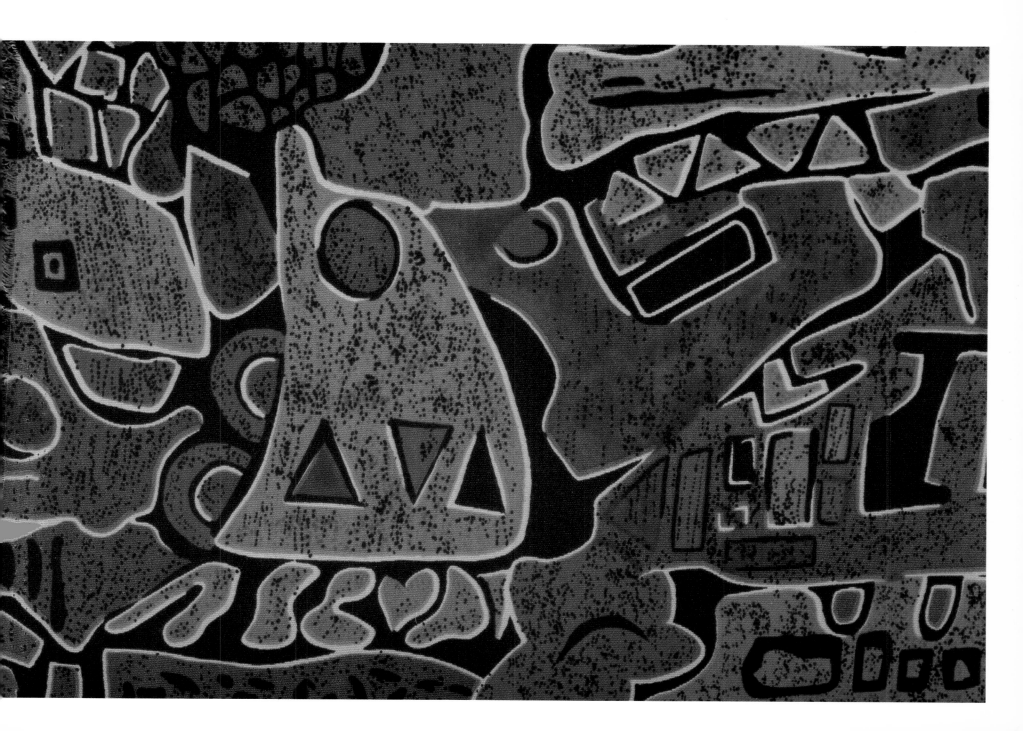

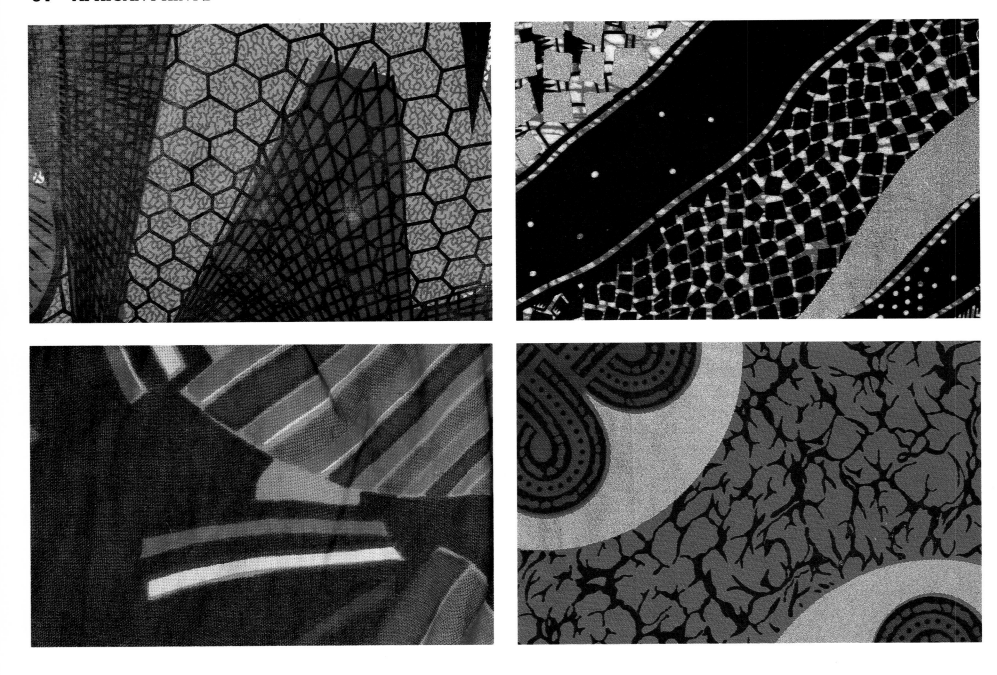

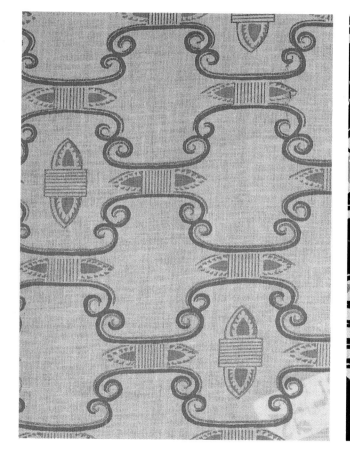
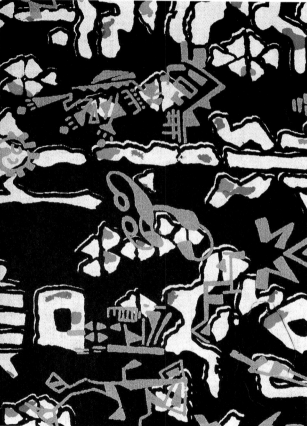
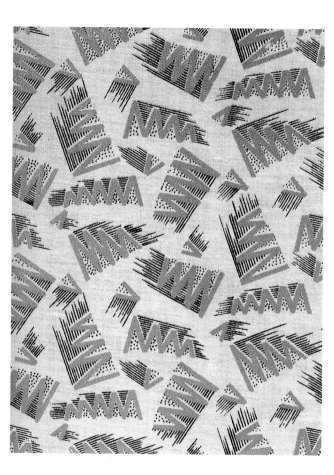

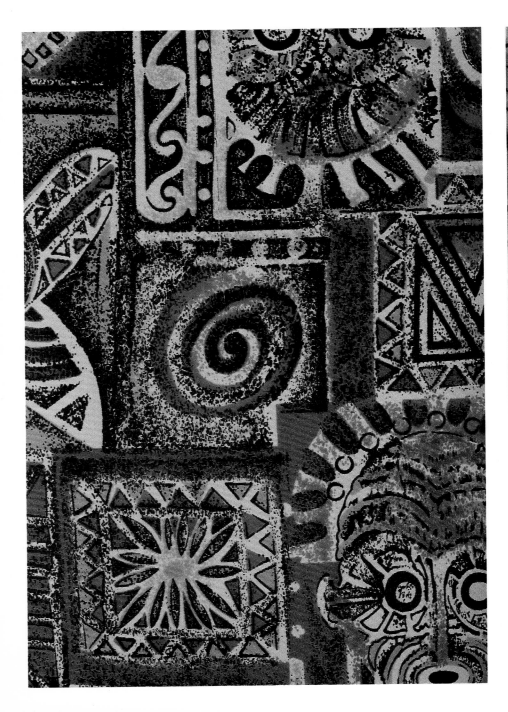

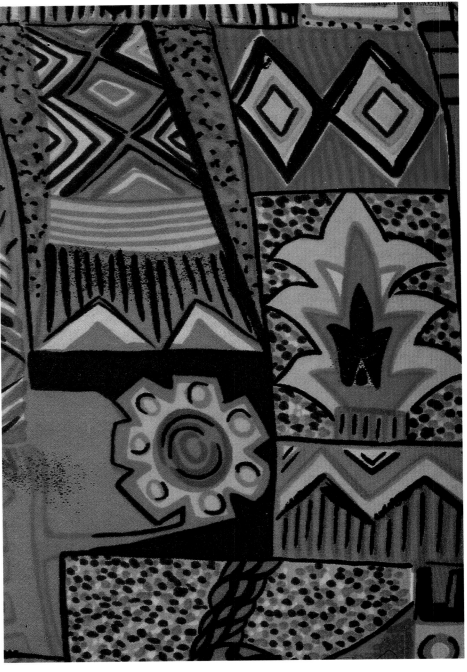

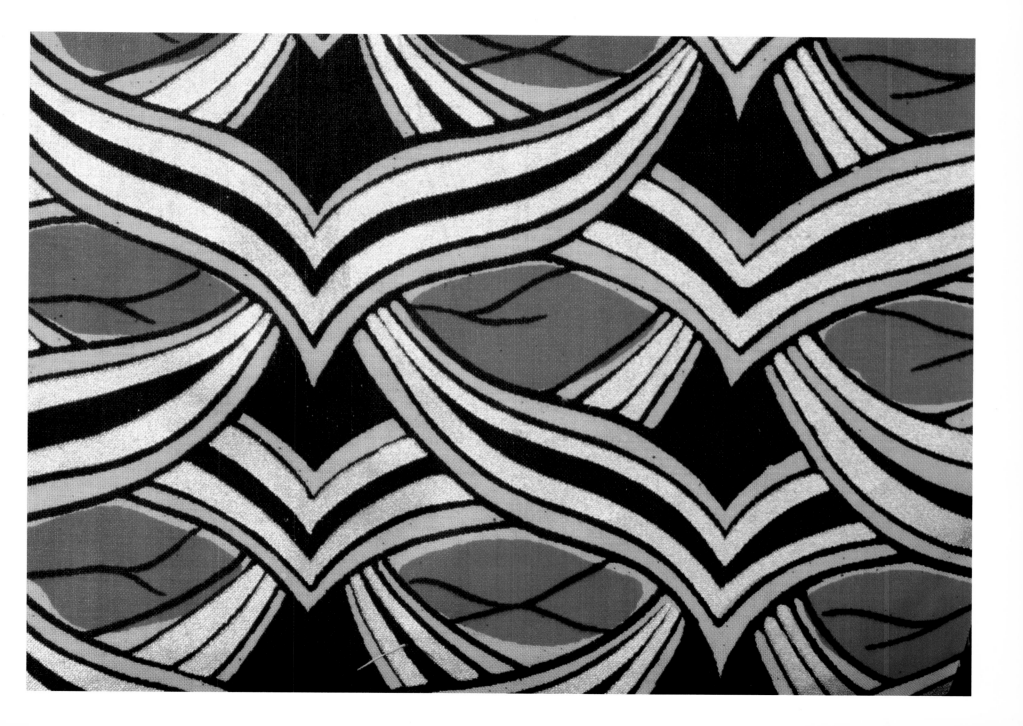

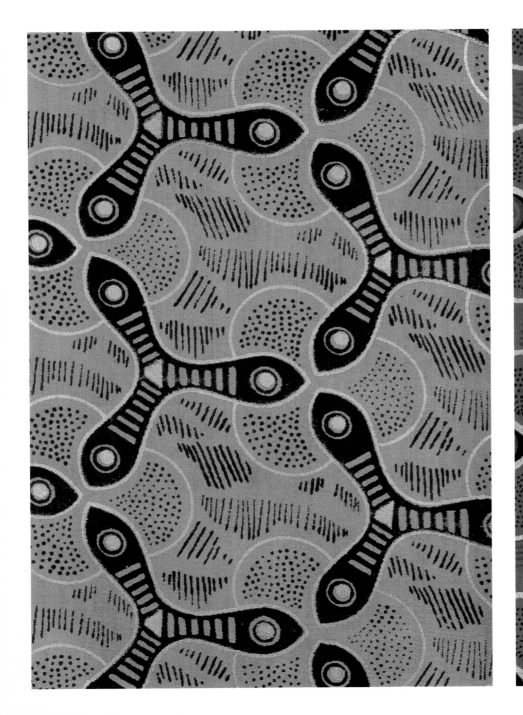

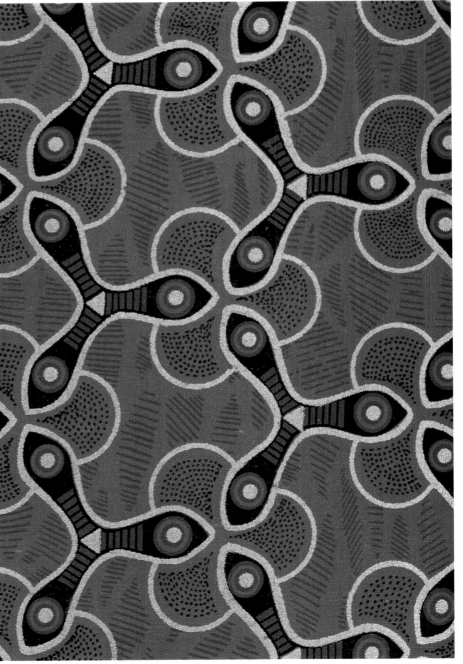

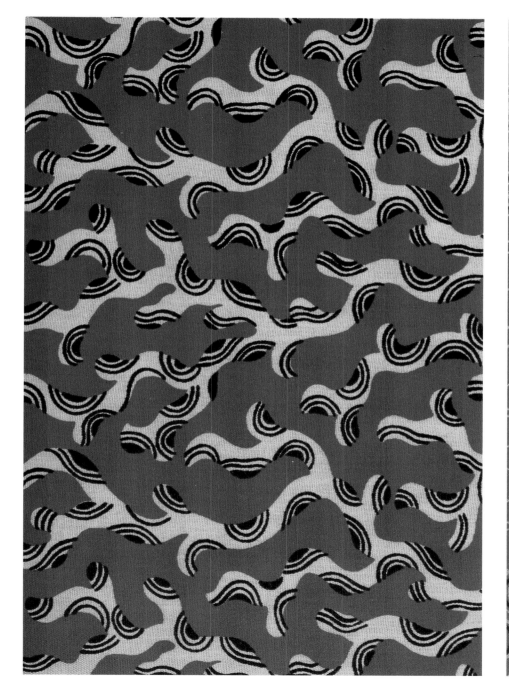

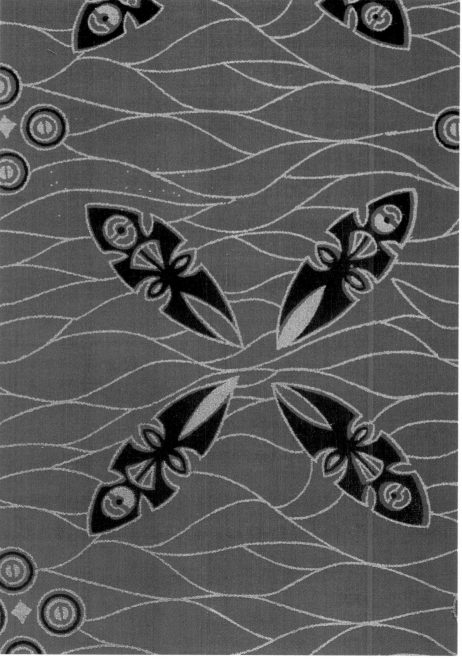

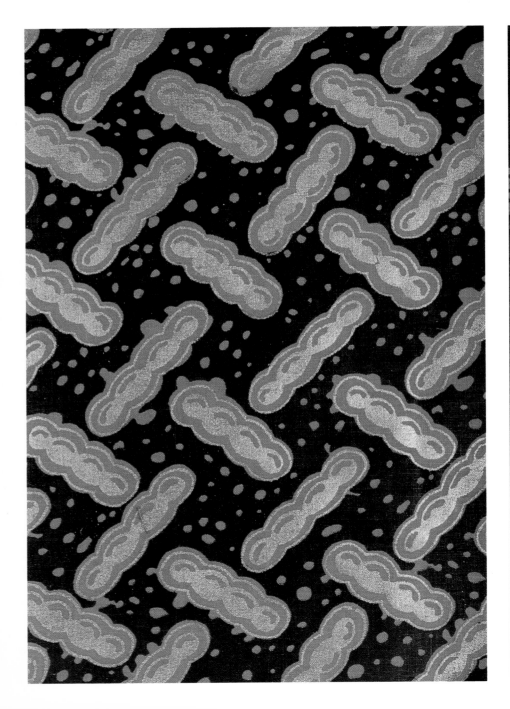

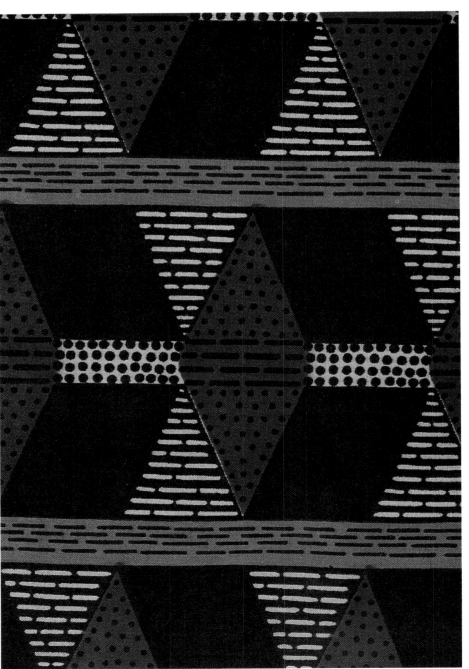

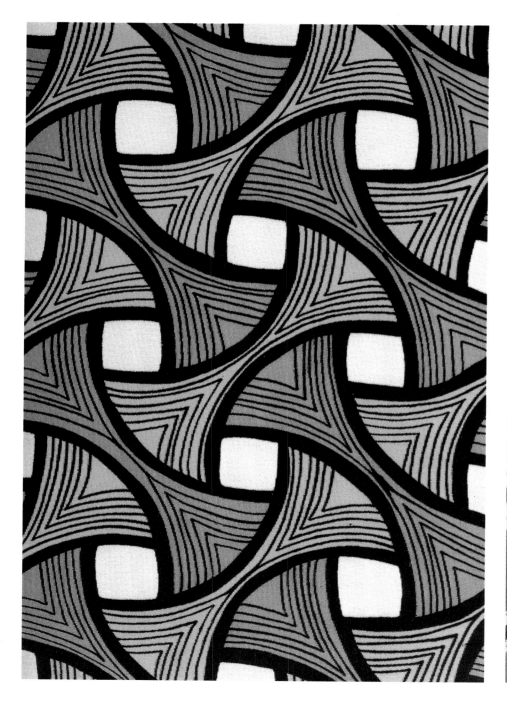

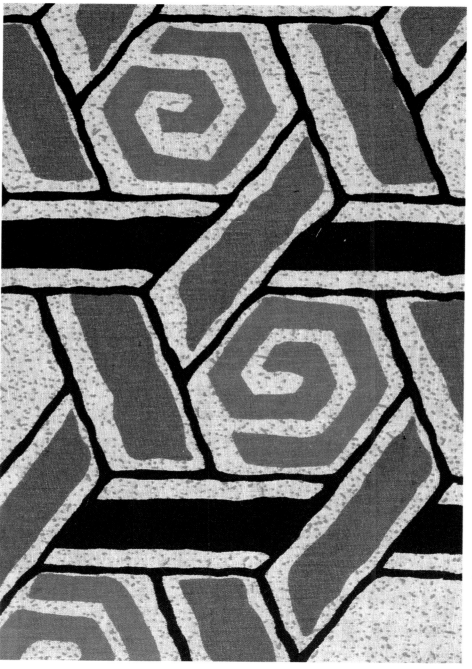

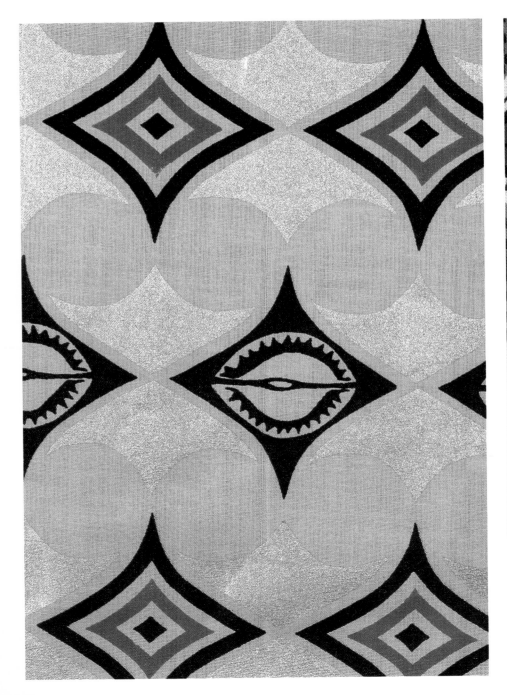

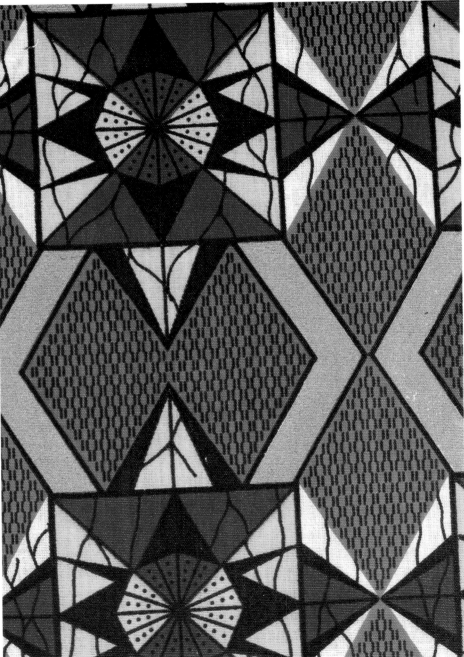

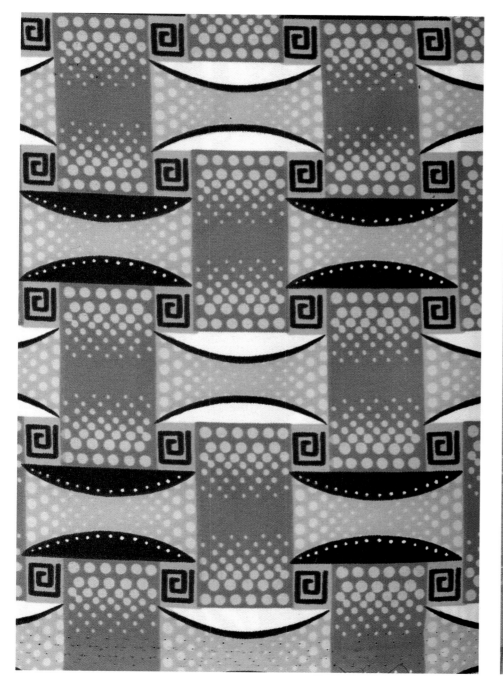

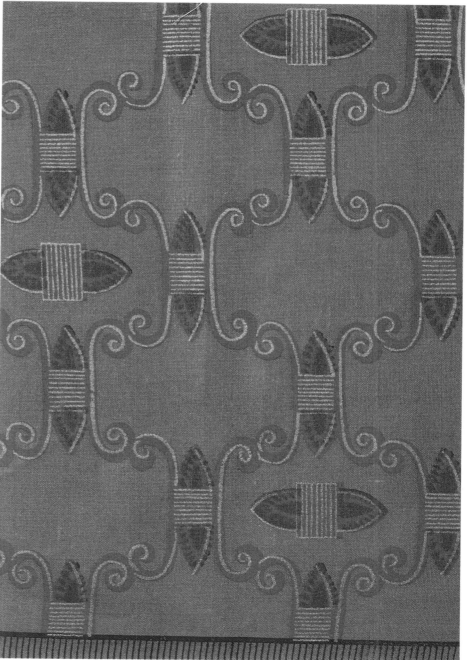

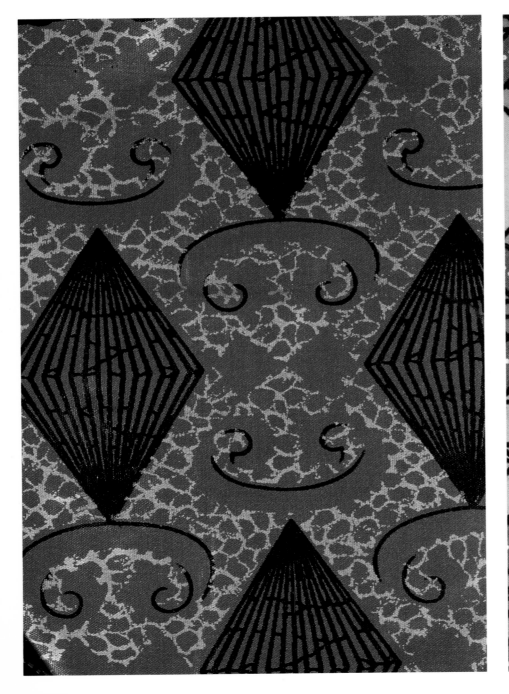
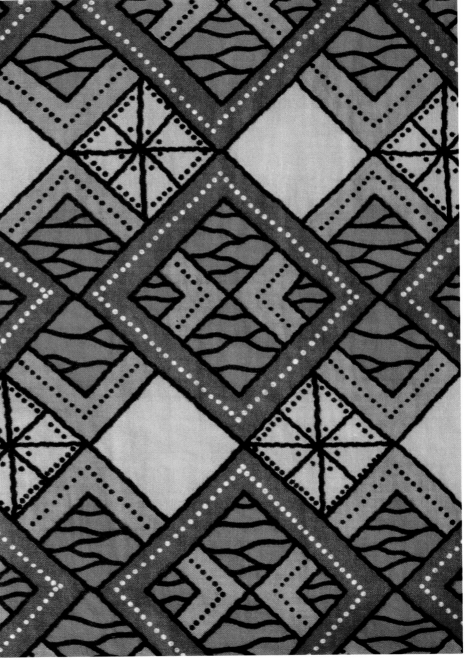

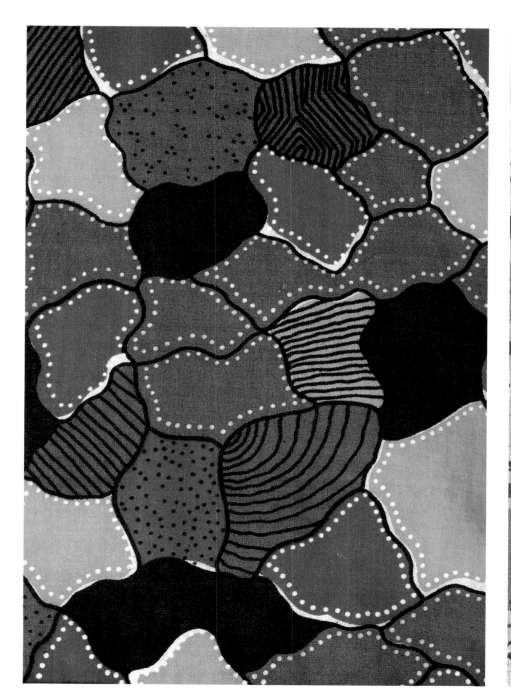

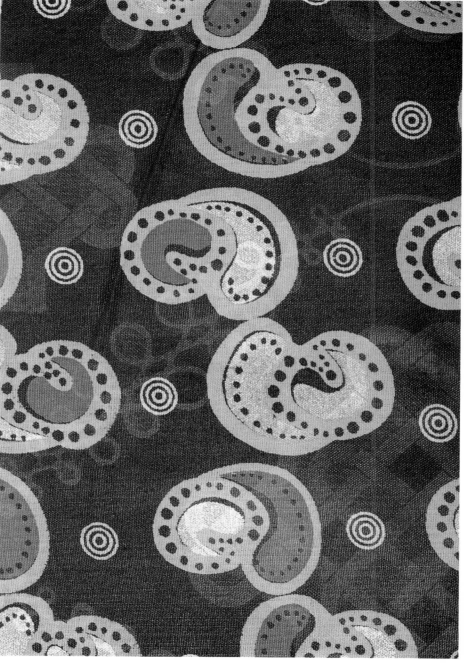

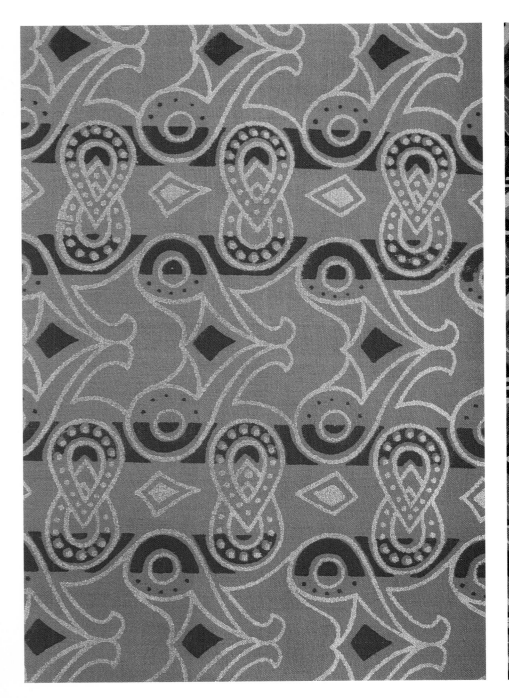

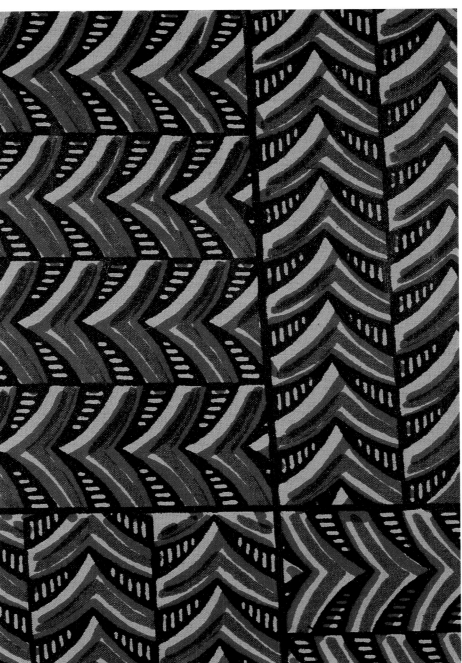

Pictorial Prints

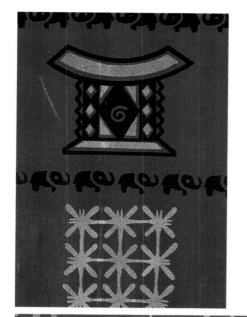
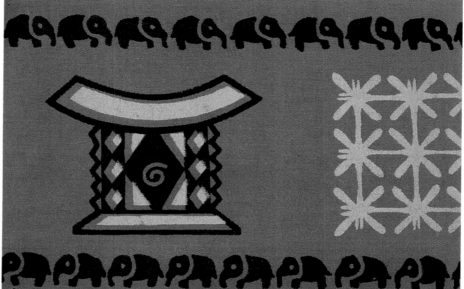
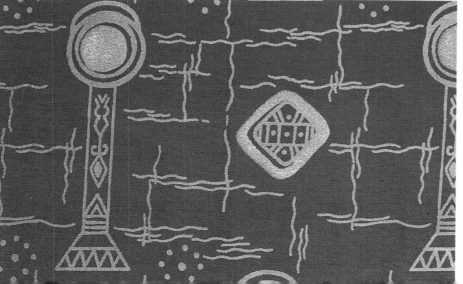
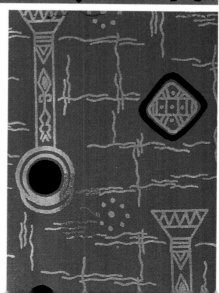

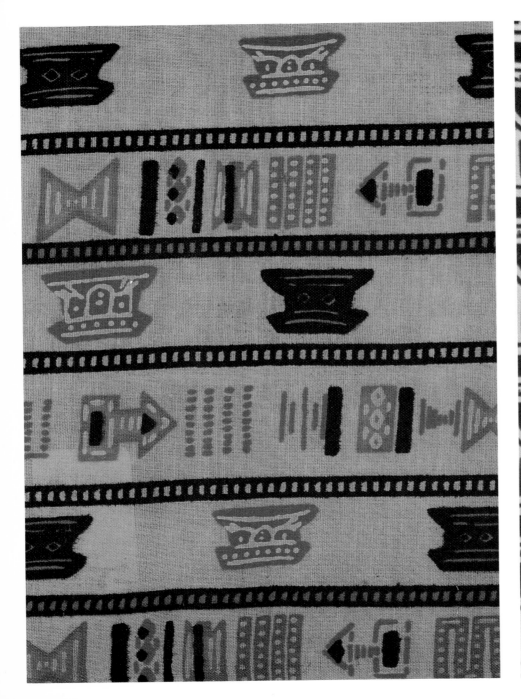

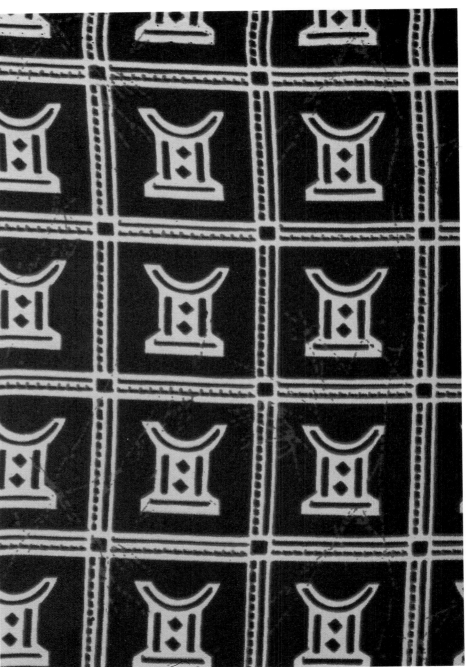

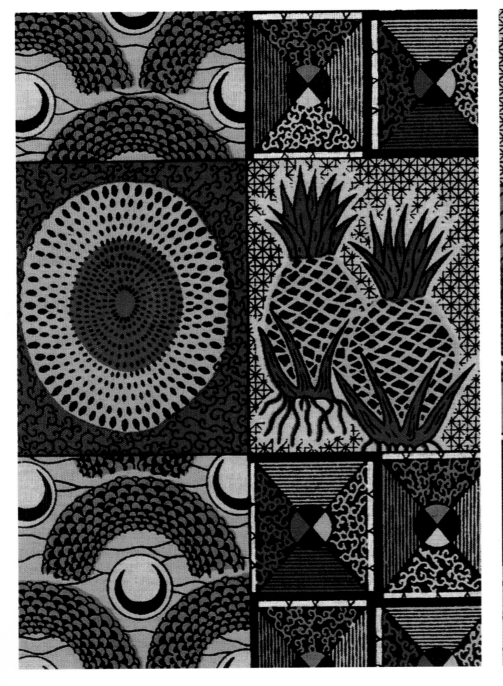

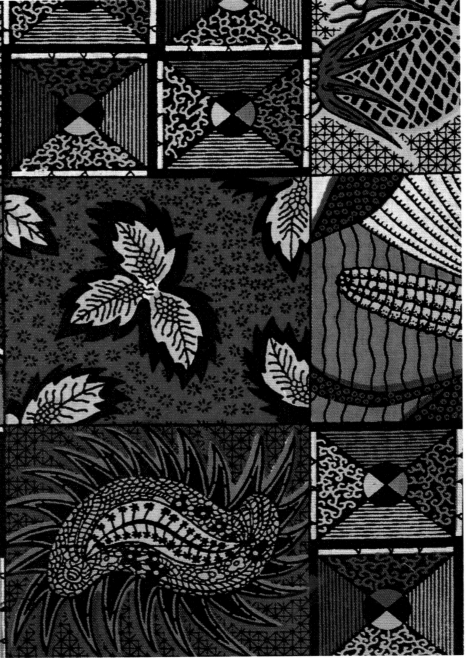

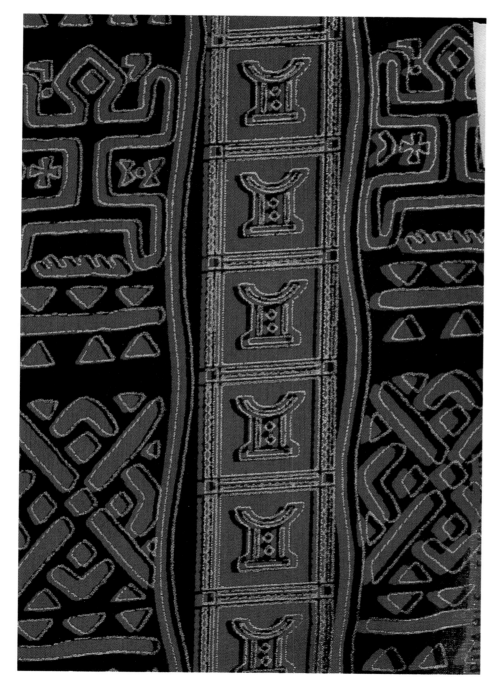

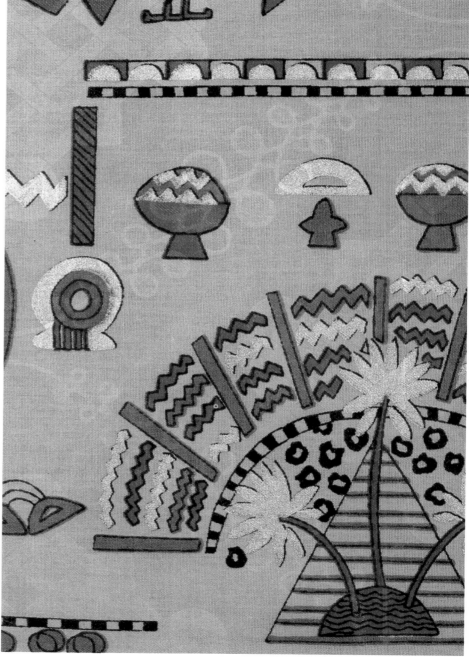

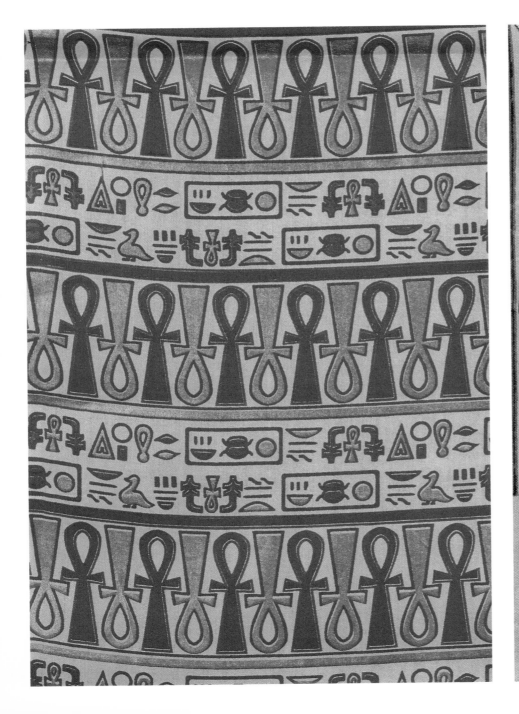

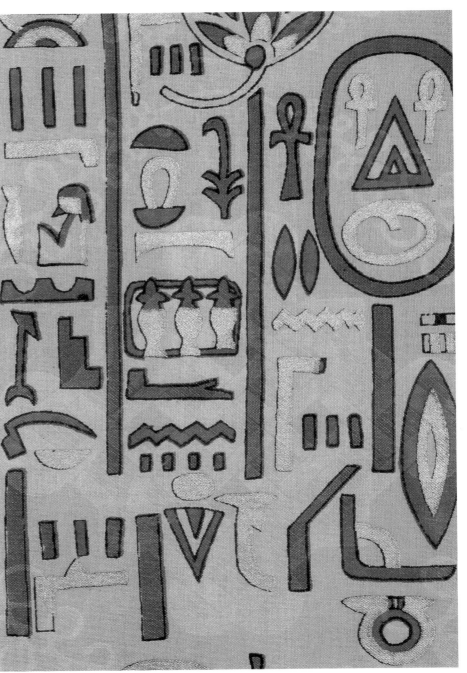

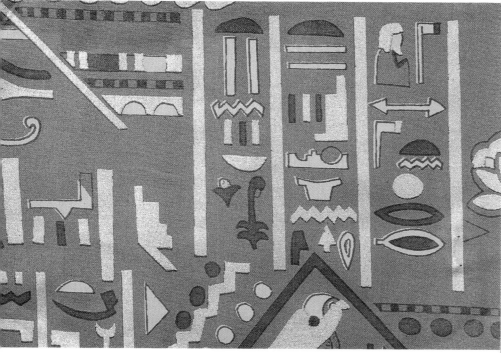

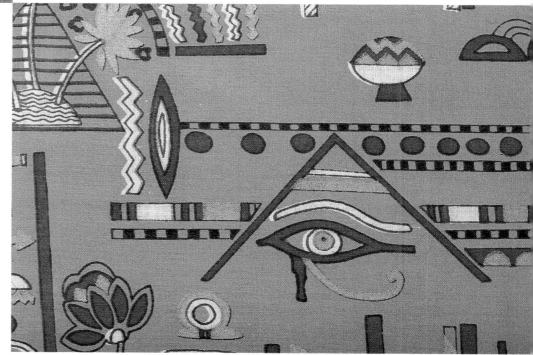

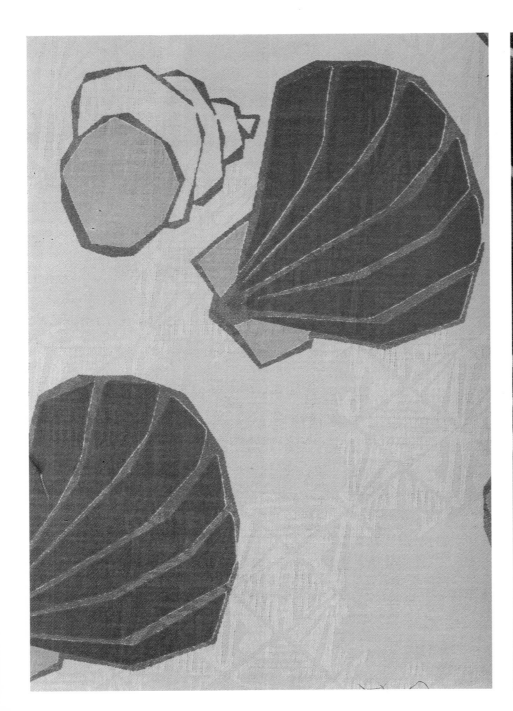
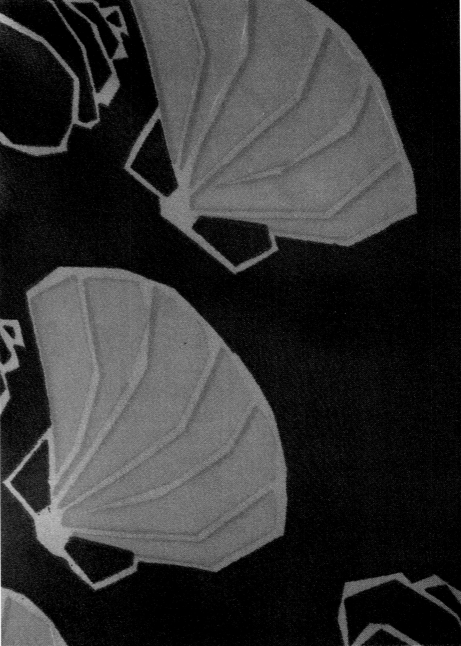

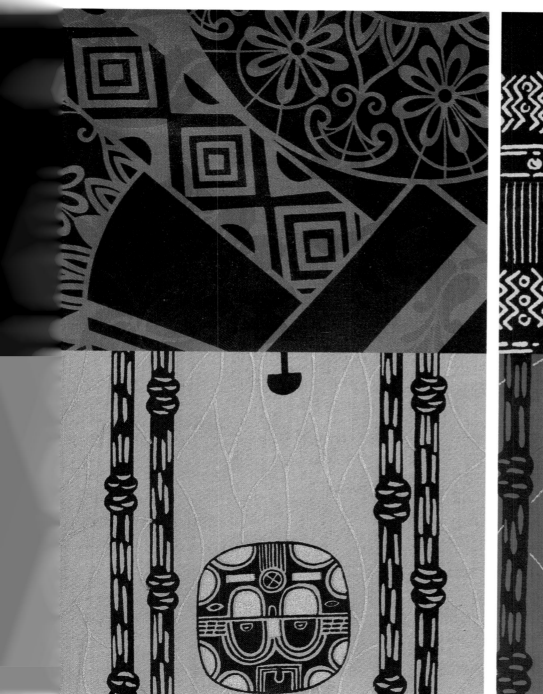

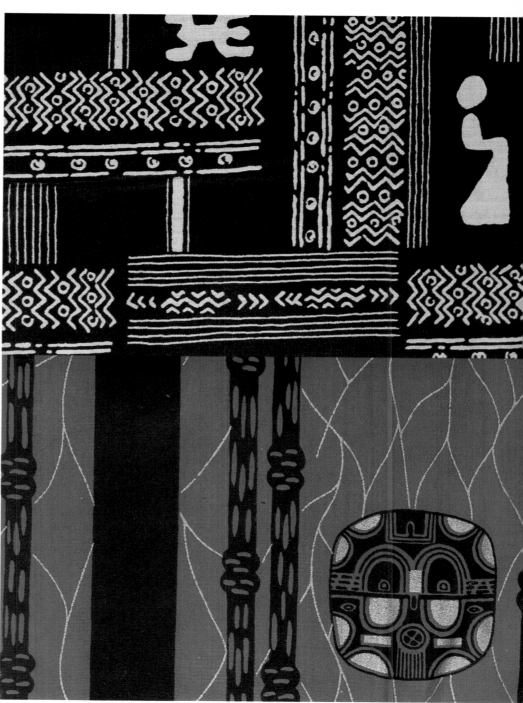

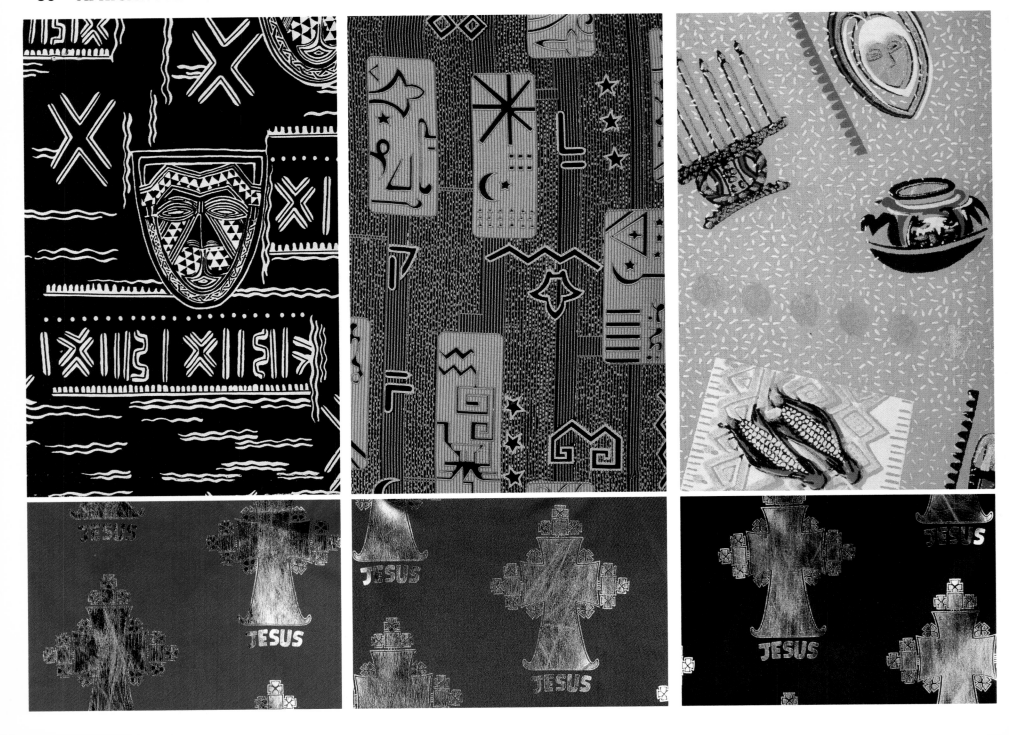

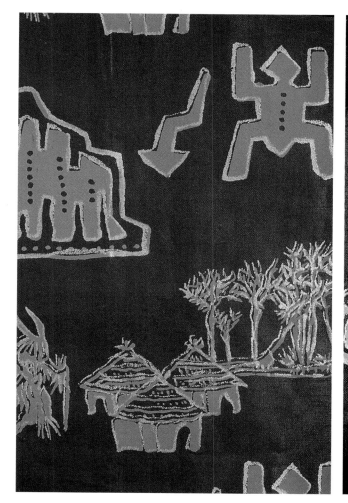
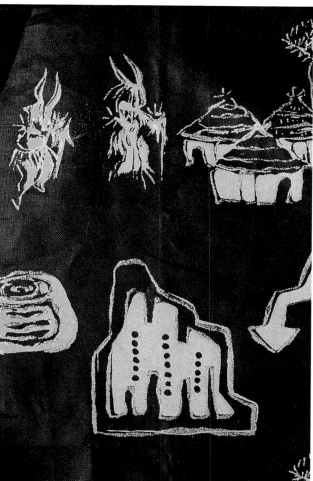
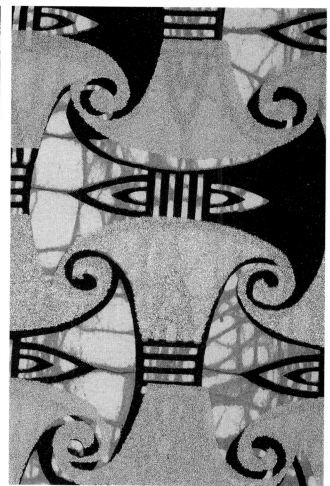

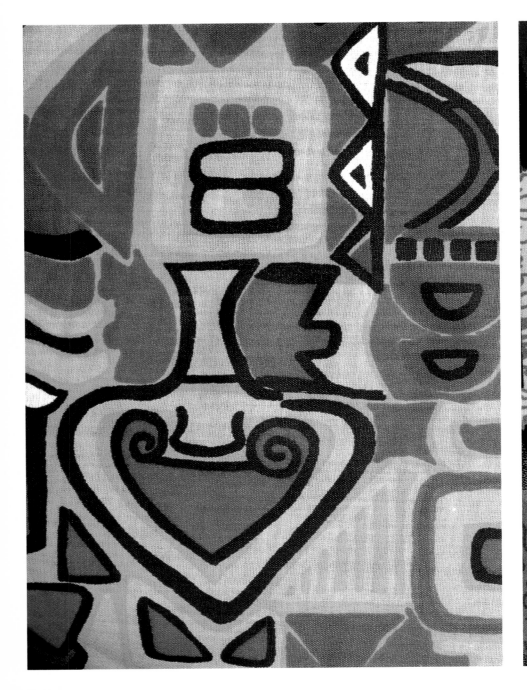
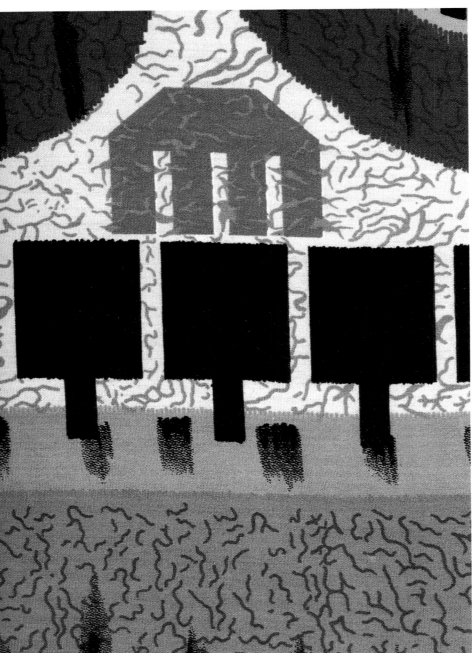

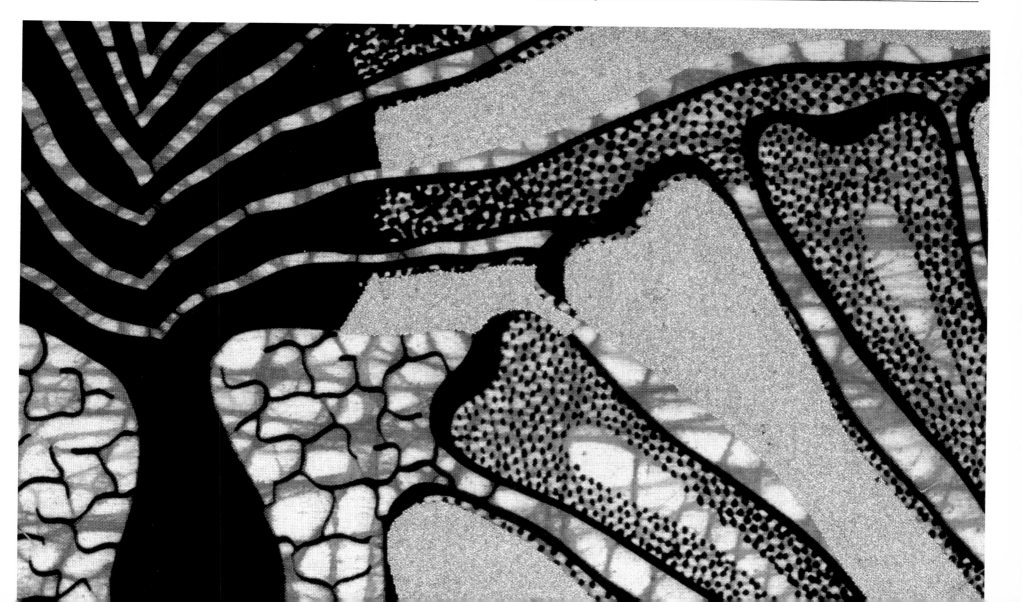

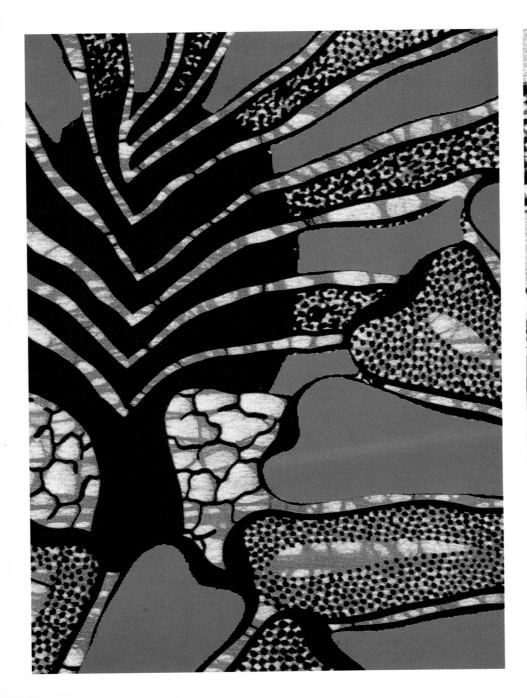
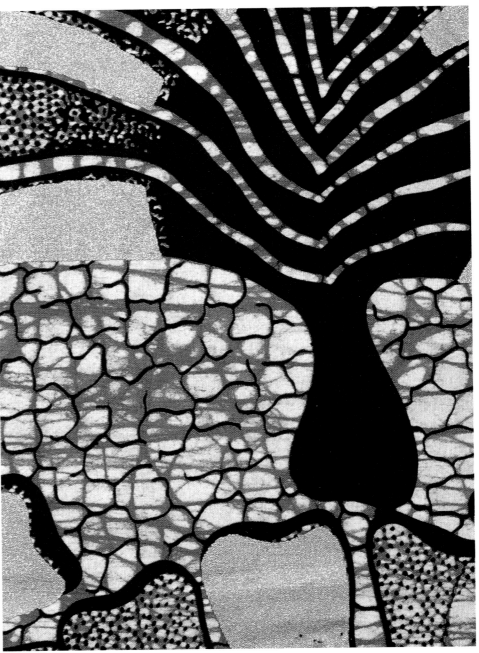

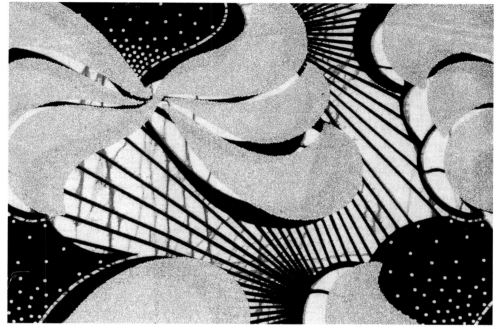

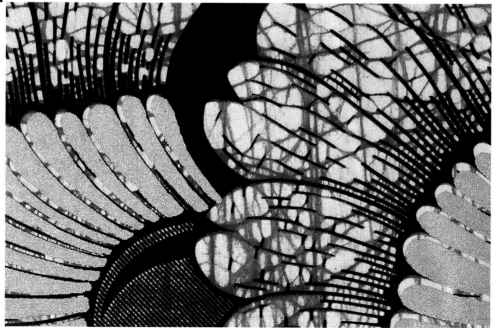

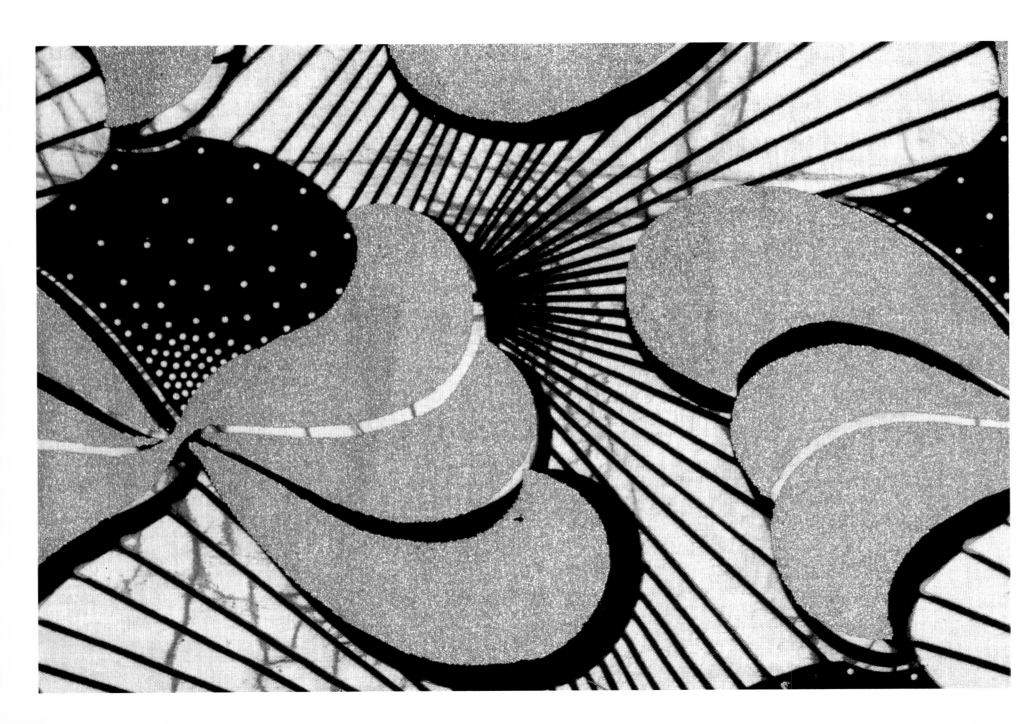

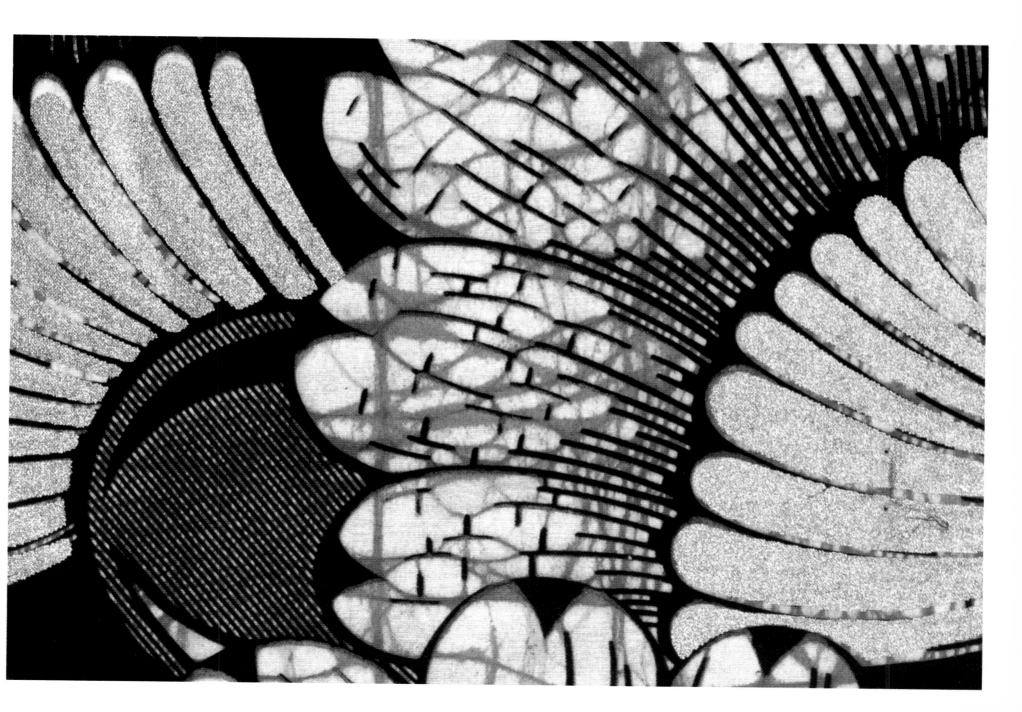

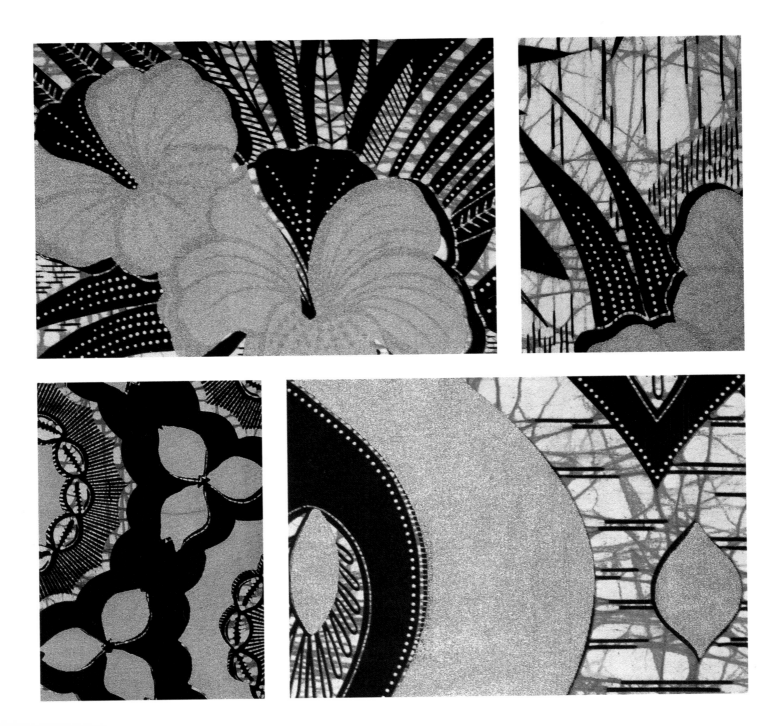

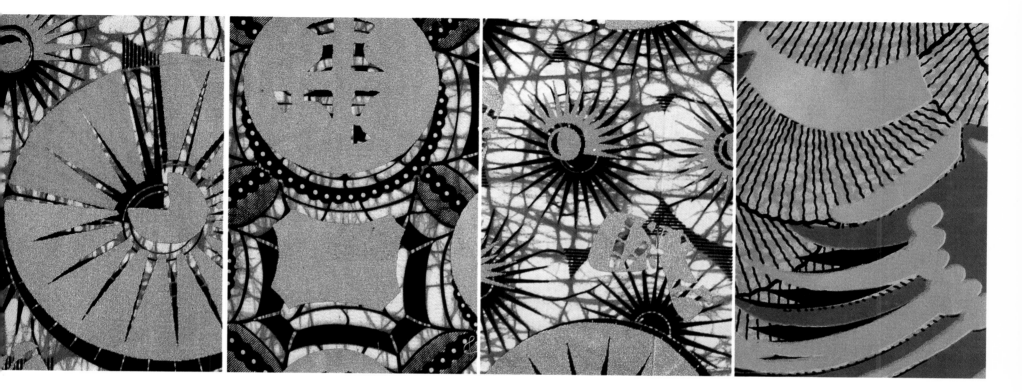

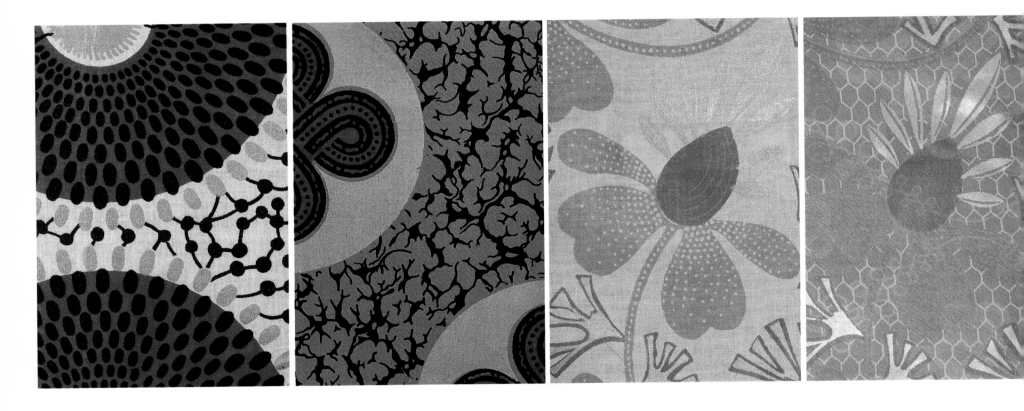

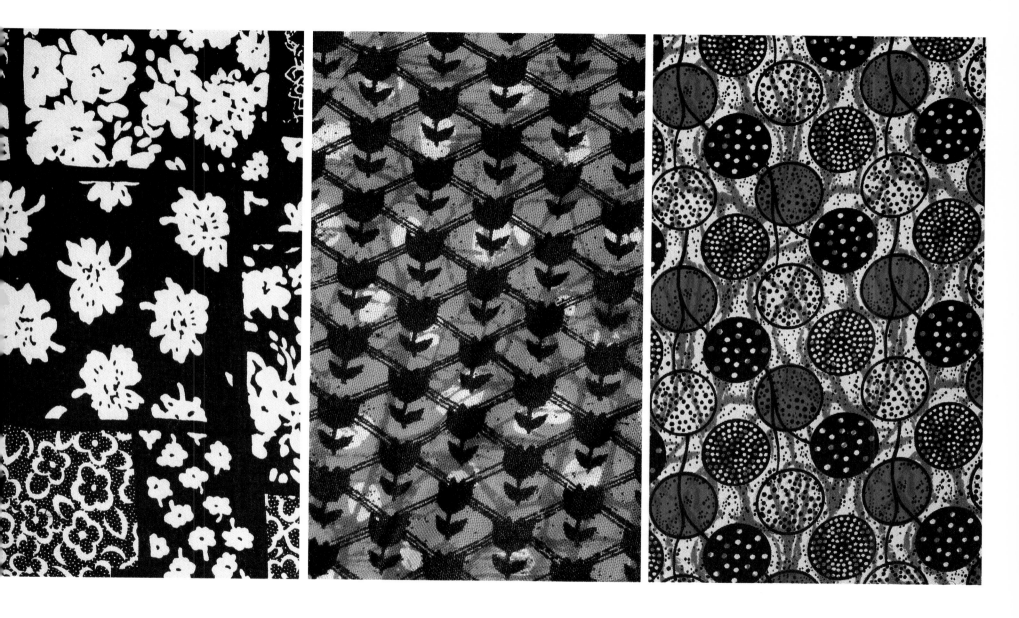

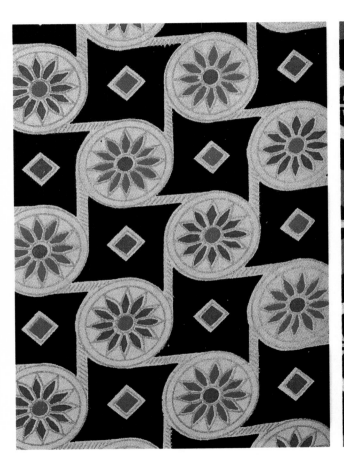
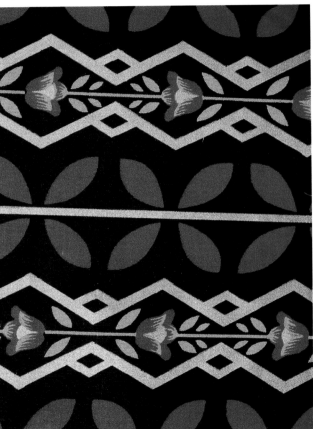
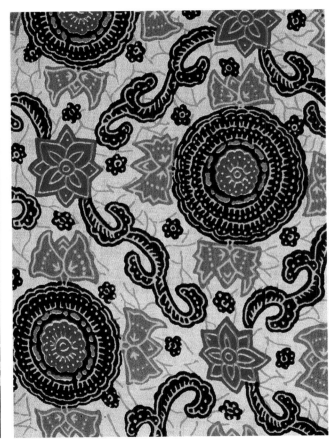

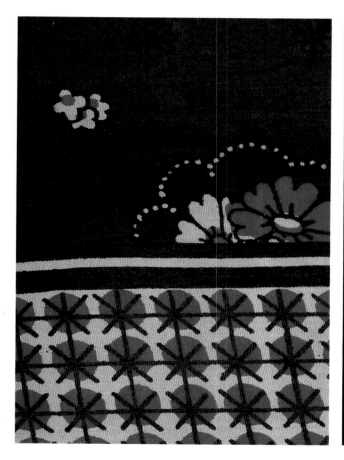
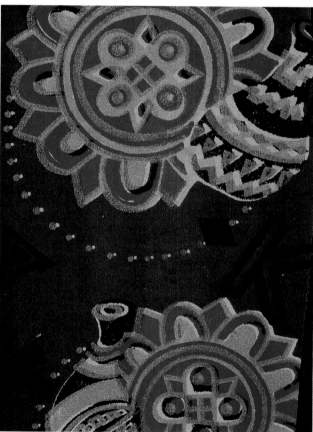
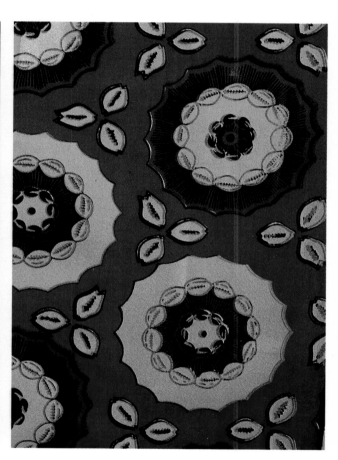

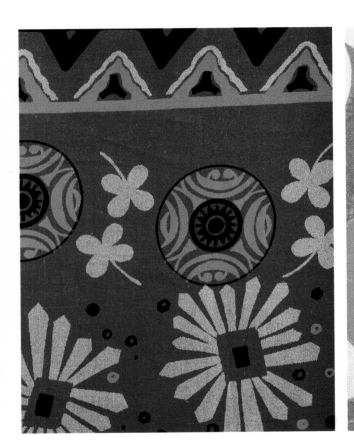
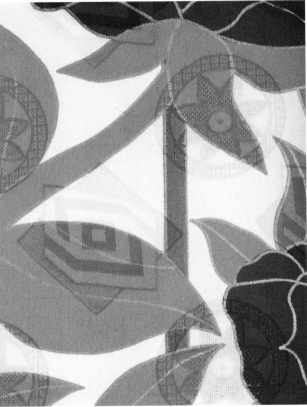
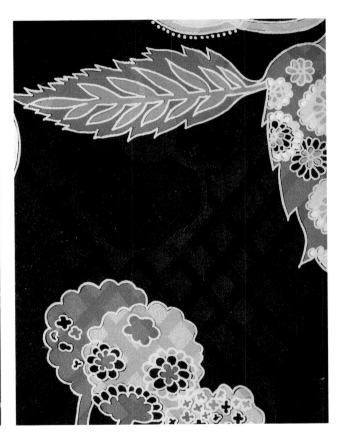

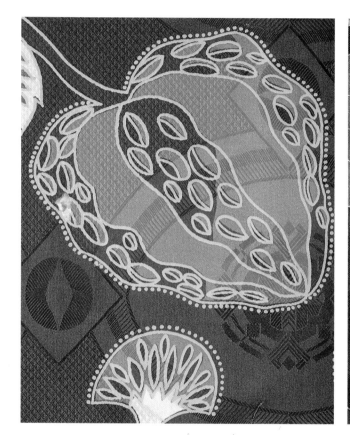
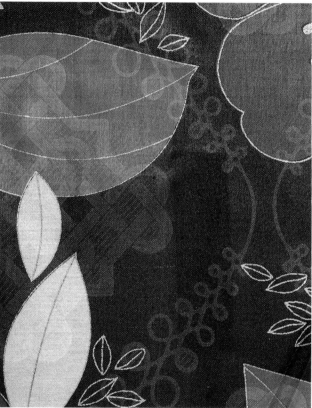
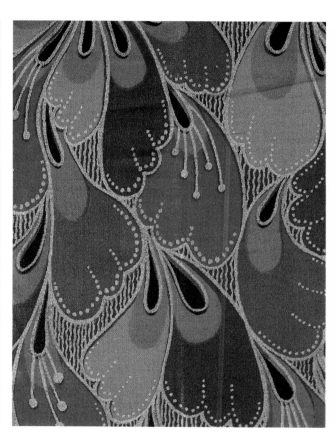

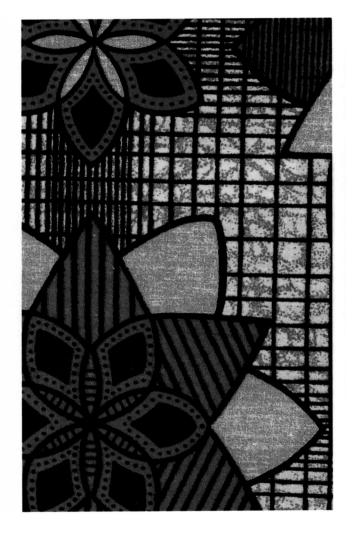
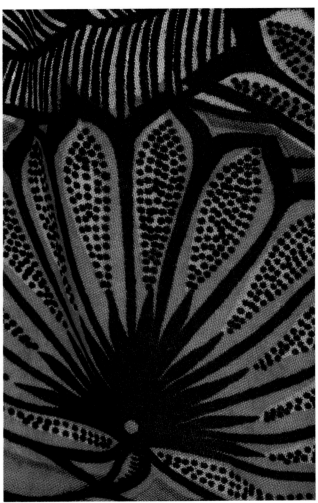
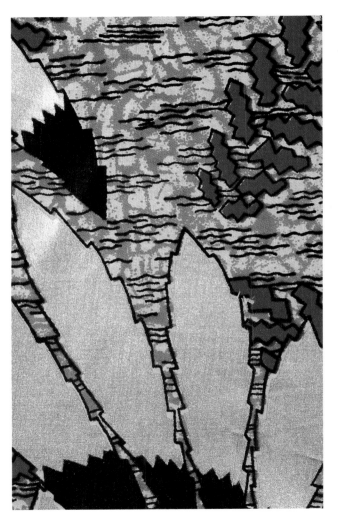

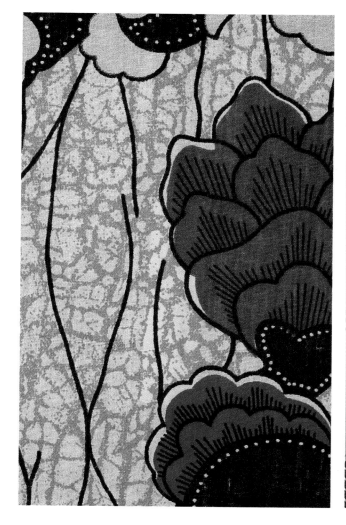

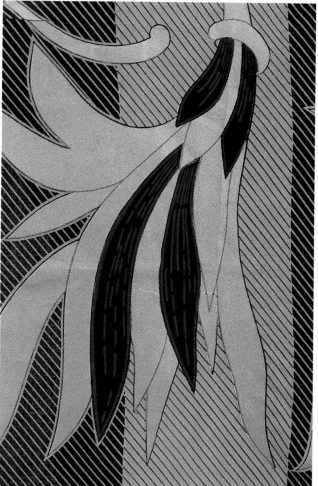

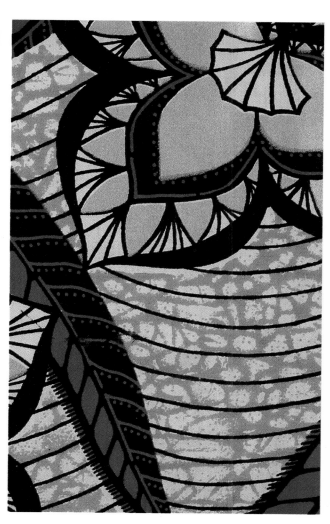

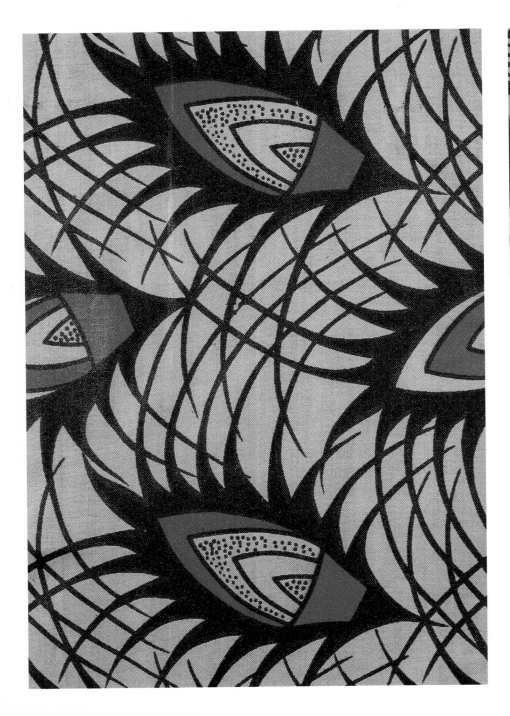

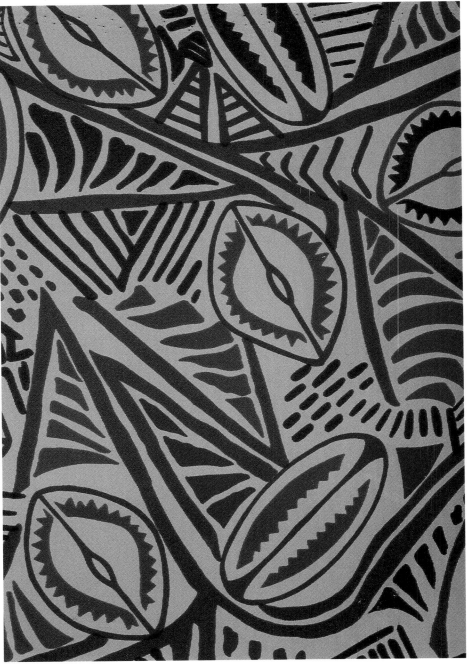

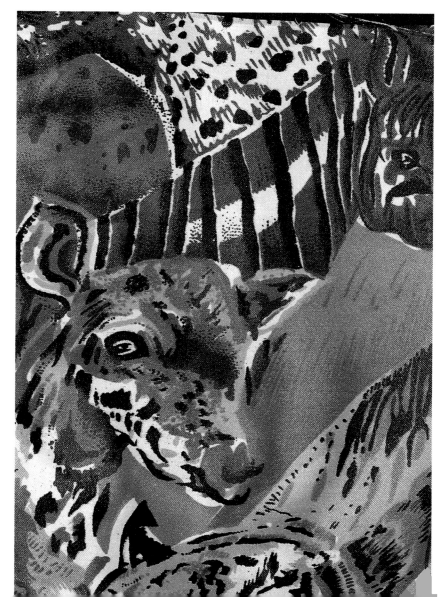

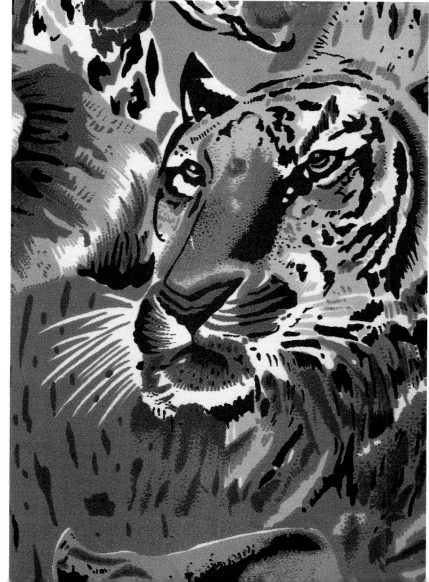

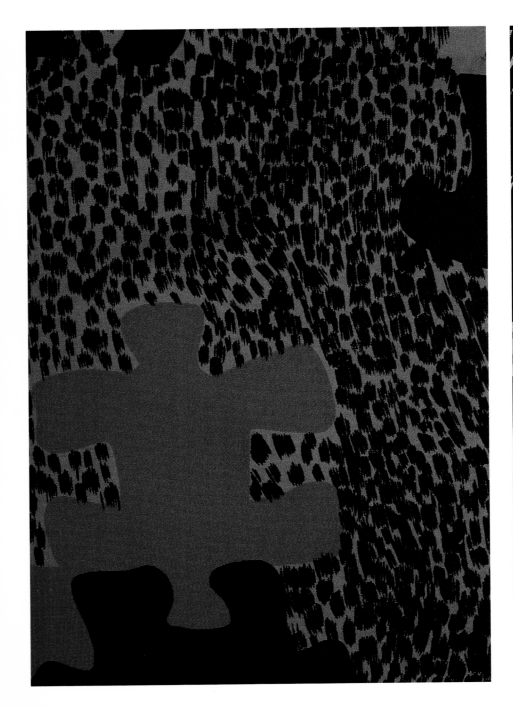

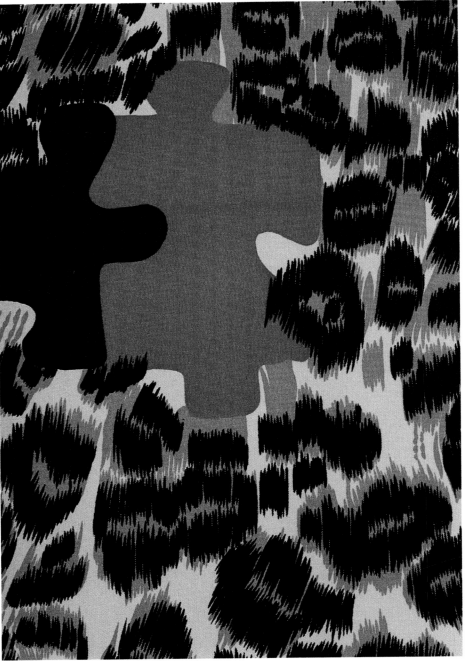

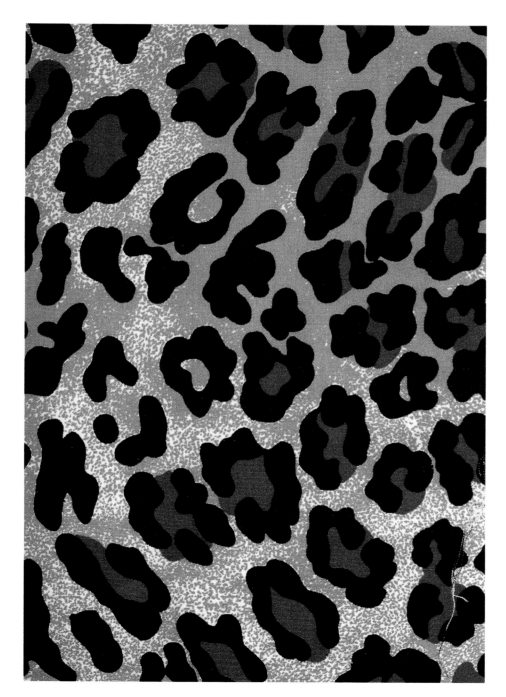
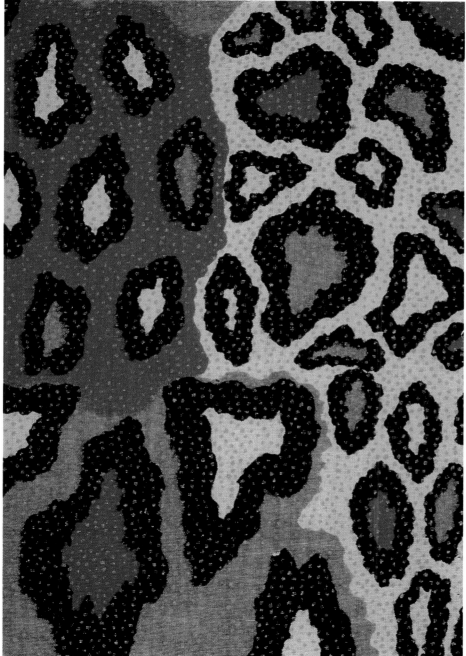

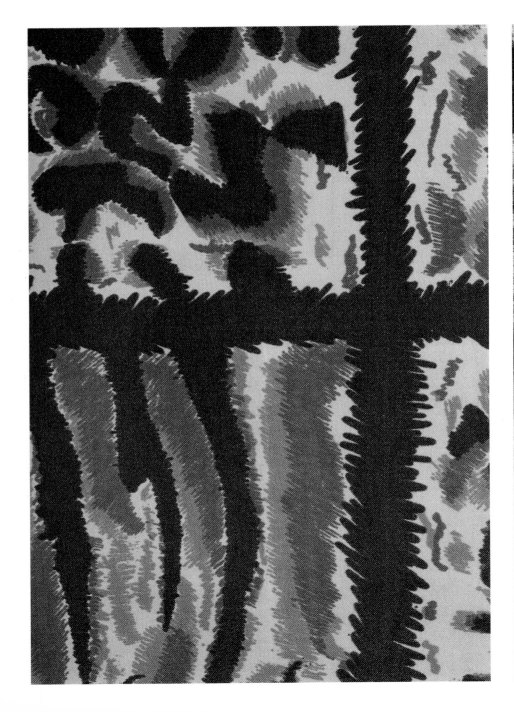

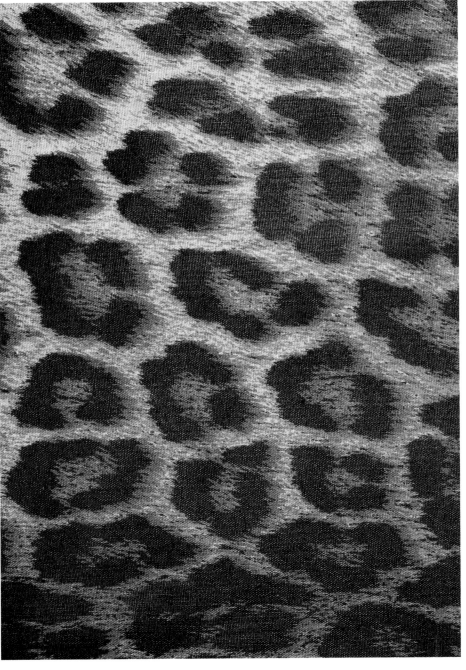

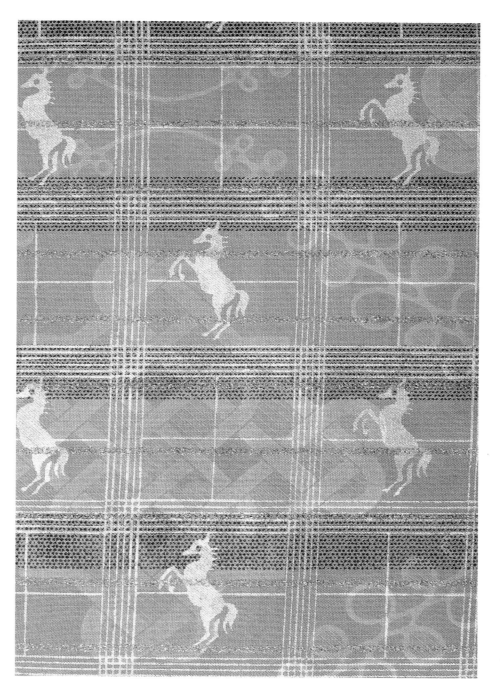
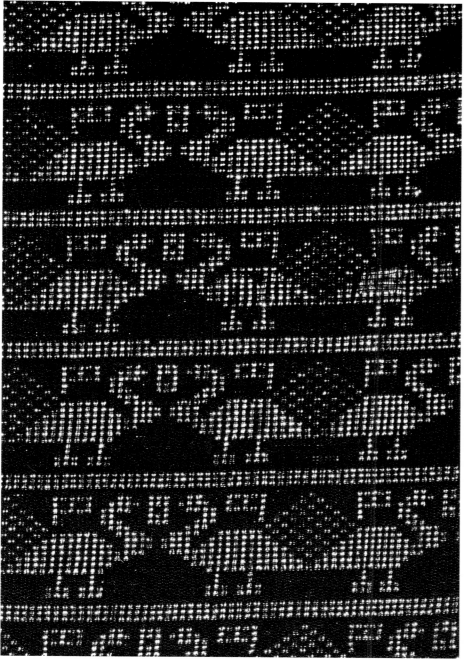

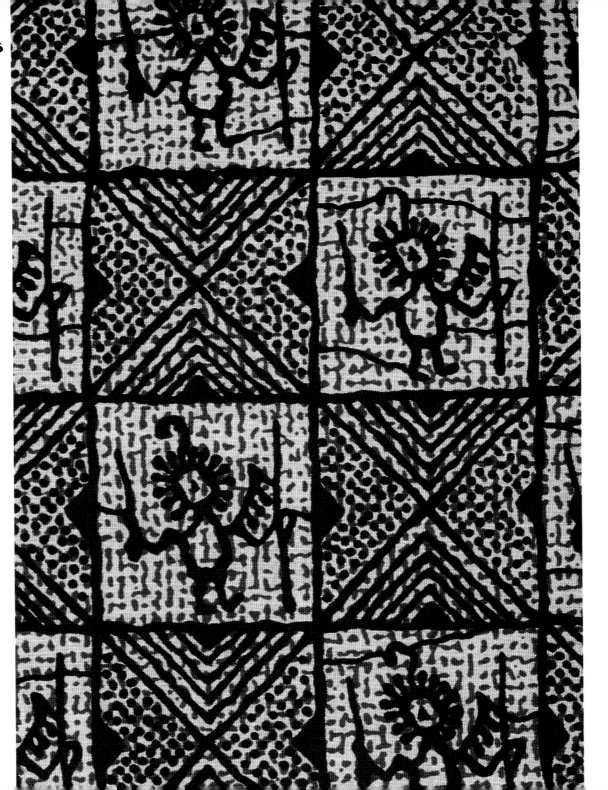

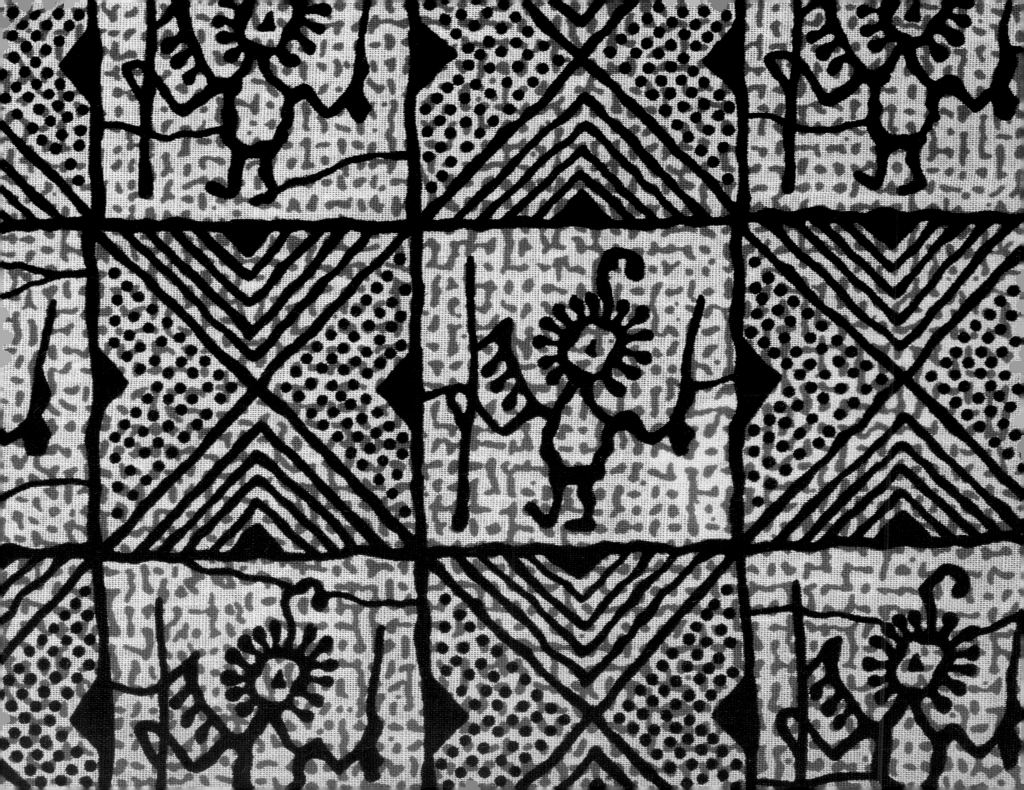

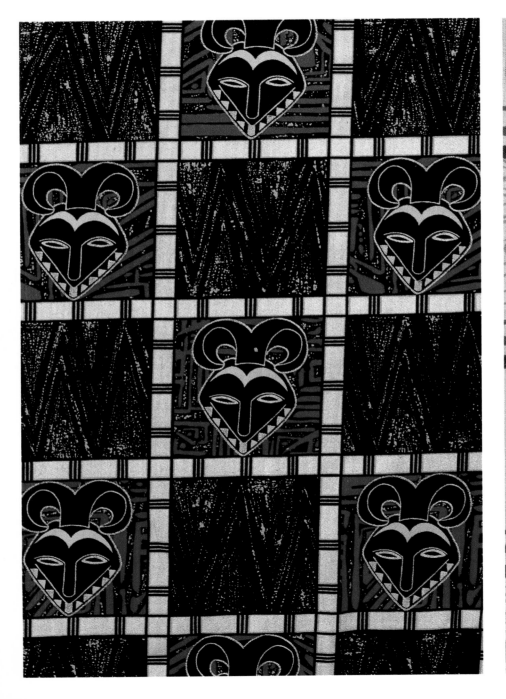

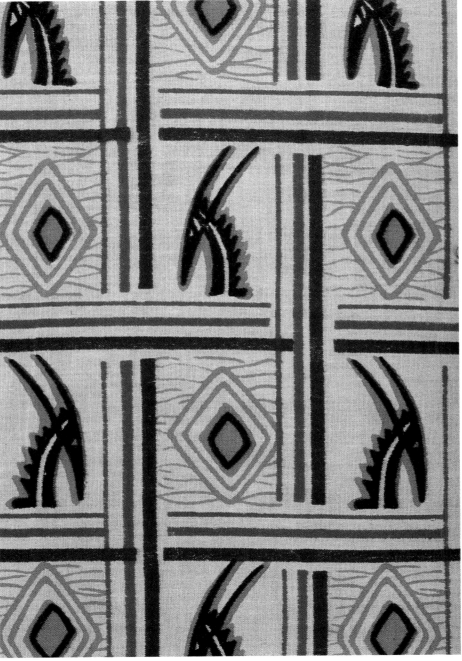

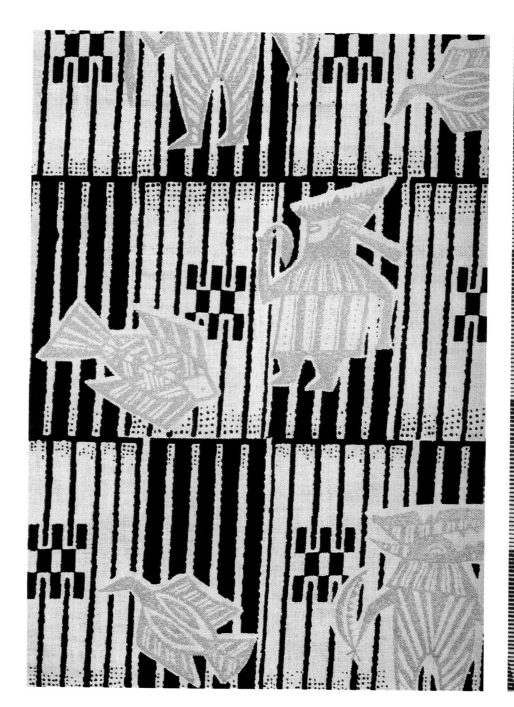

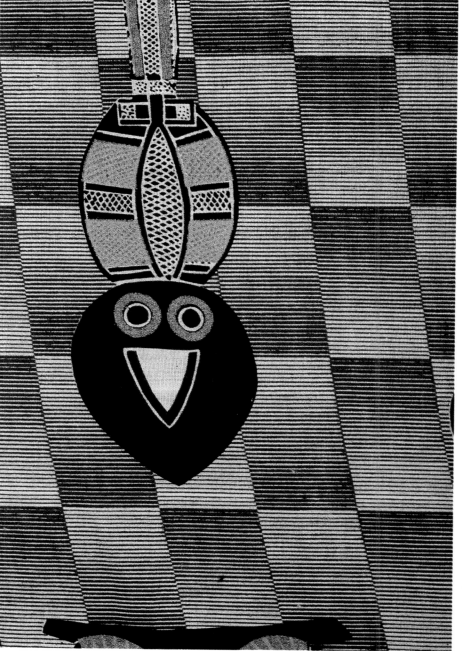

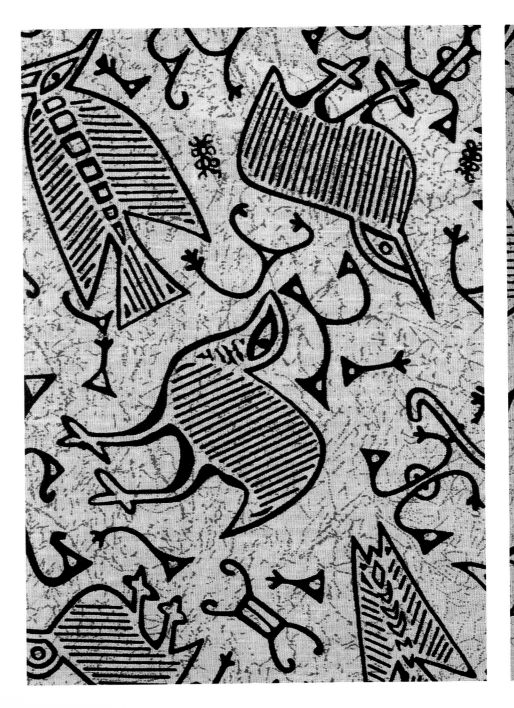
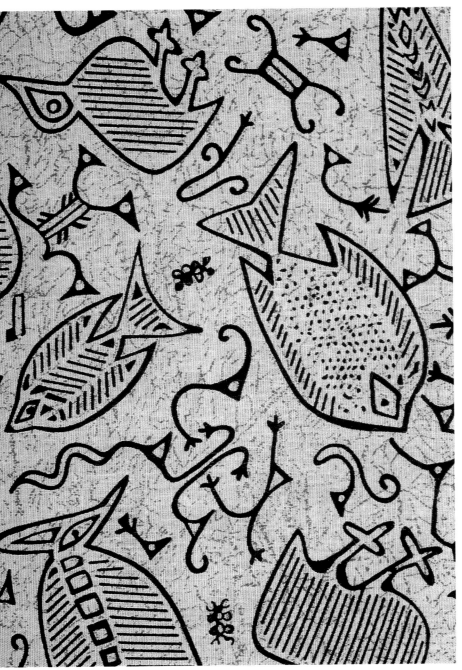

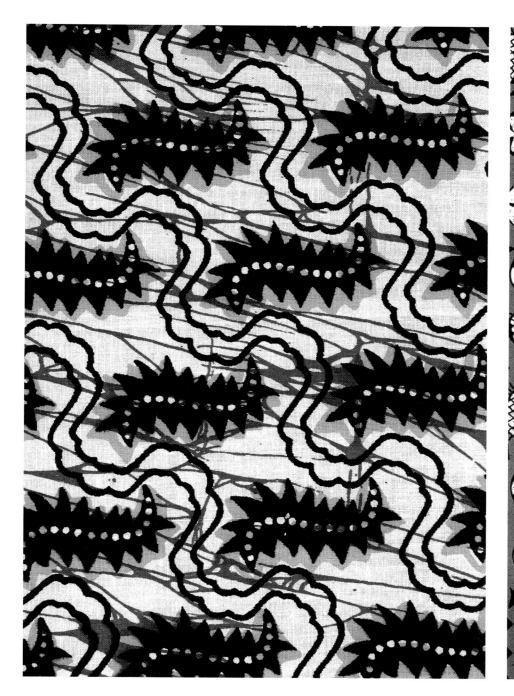

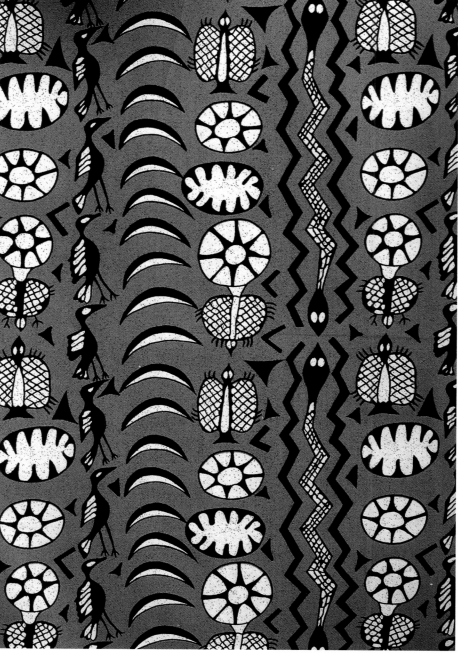

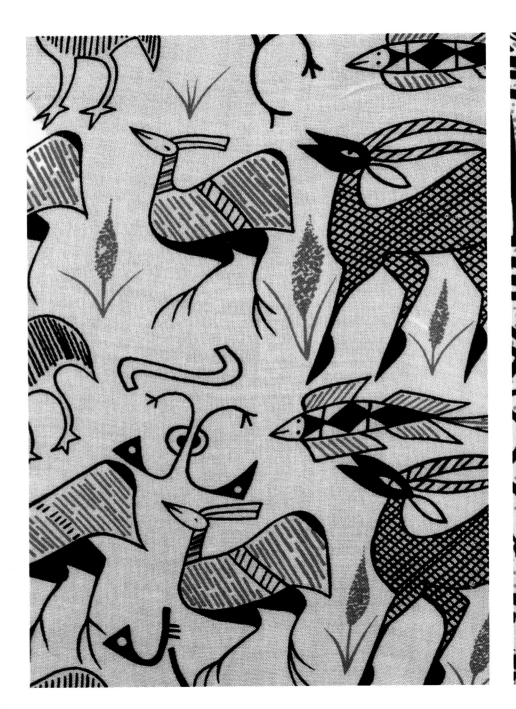

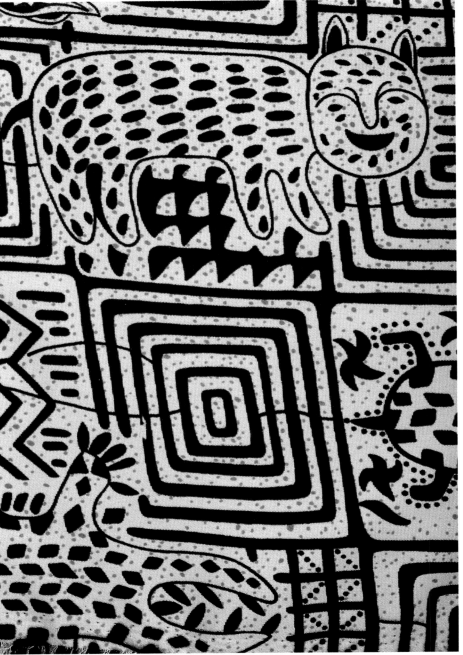

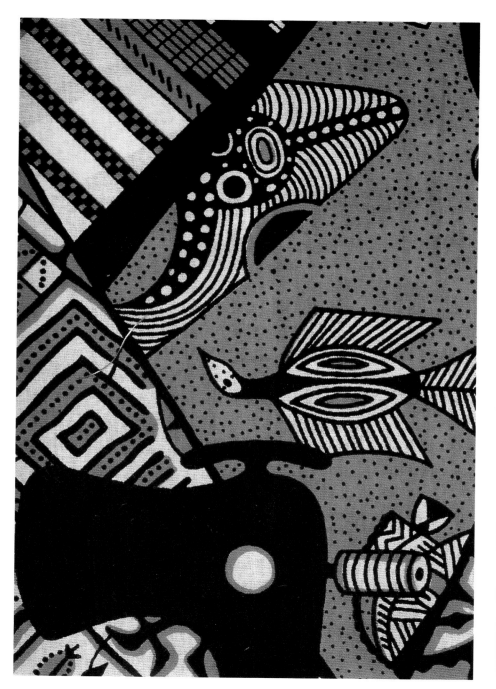
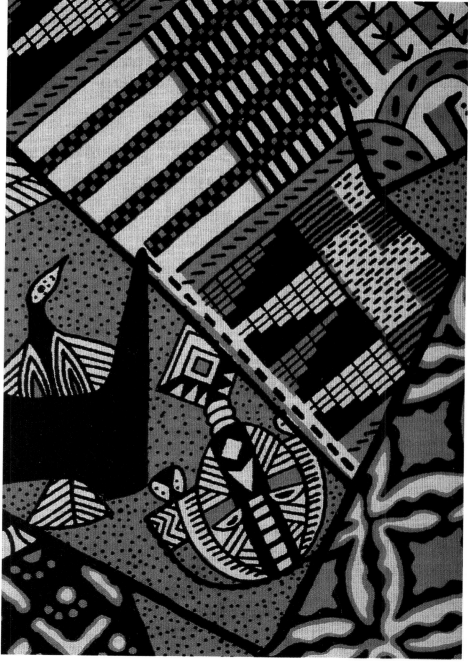

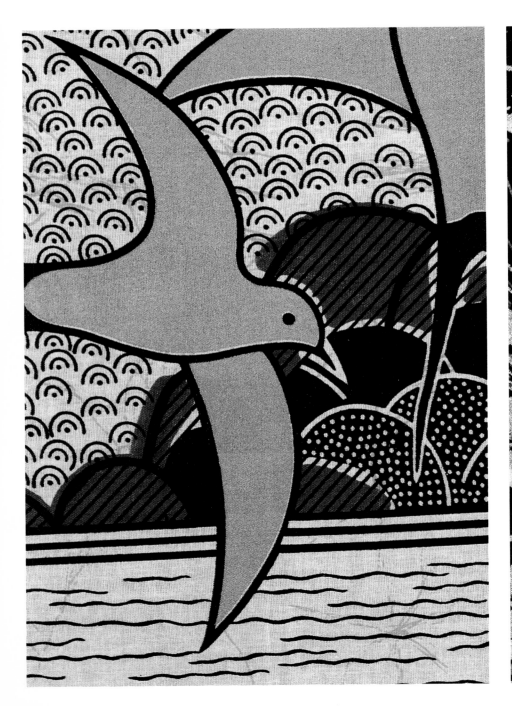

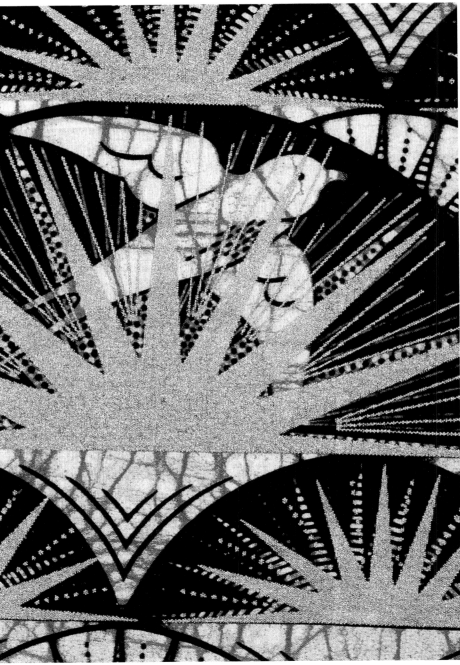

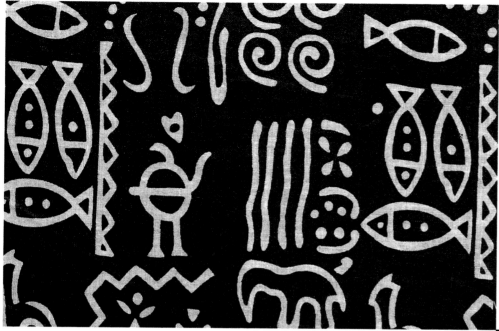

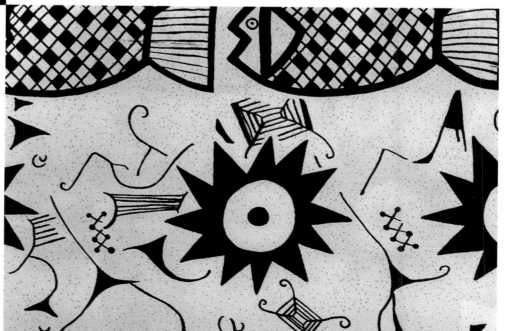

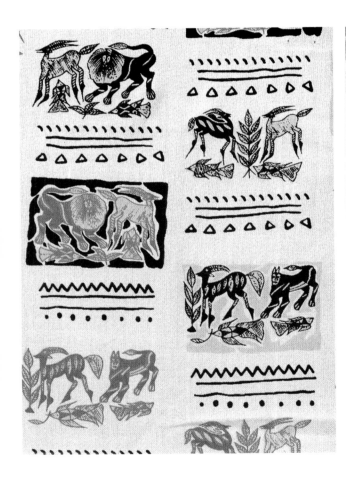
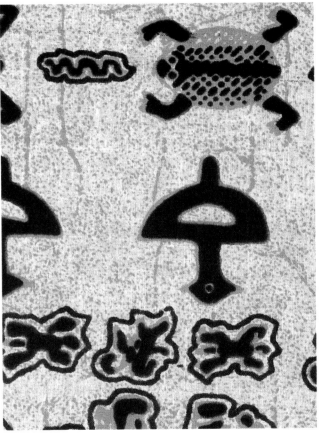
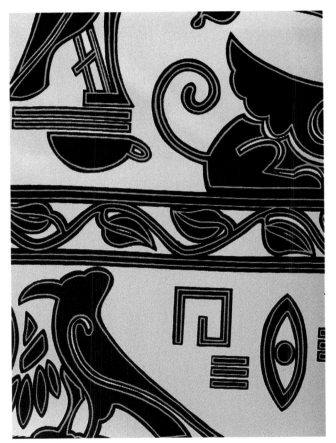

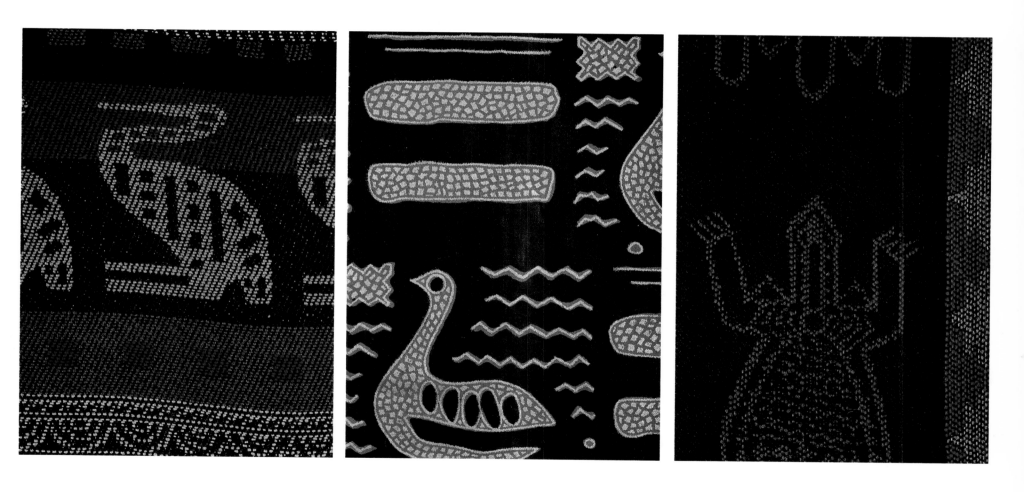

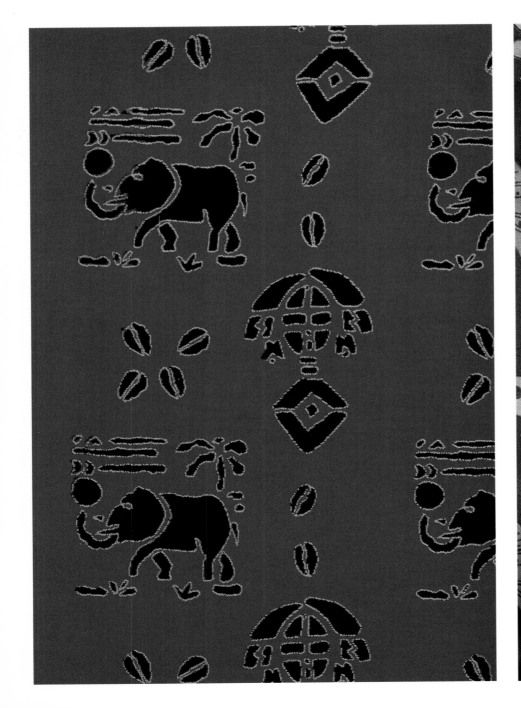

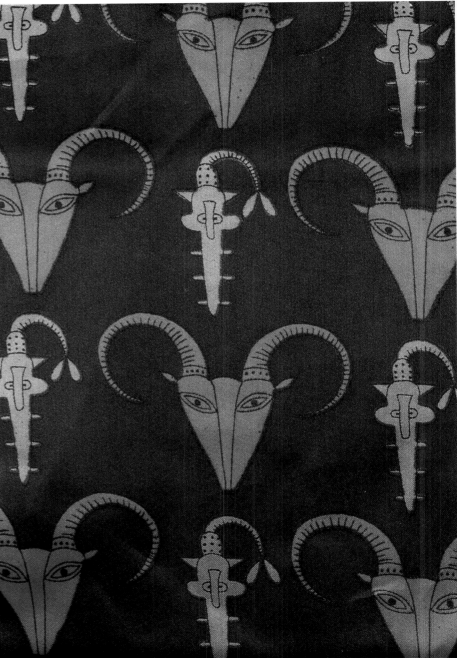

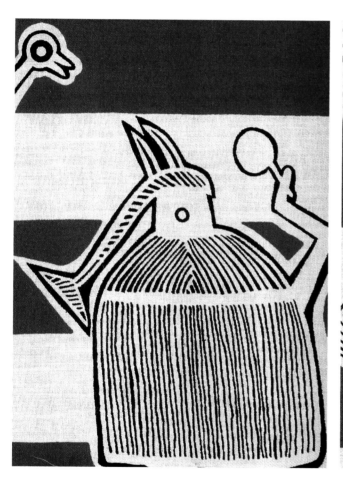

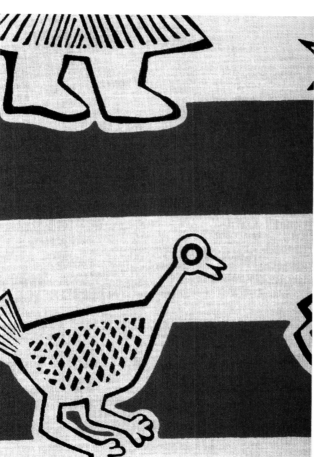

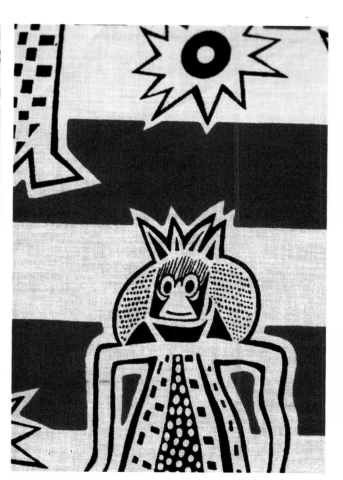

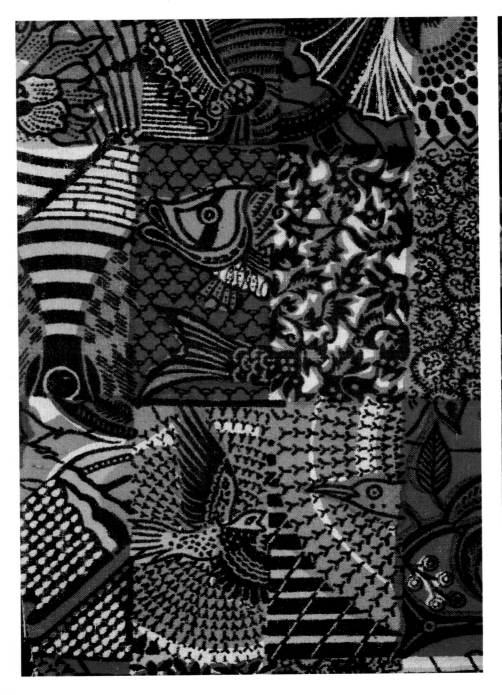

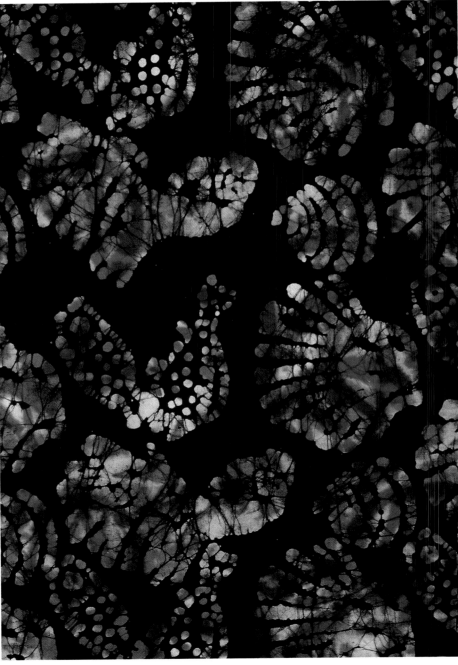

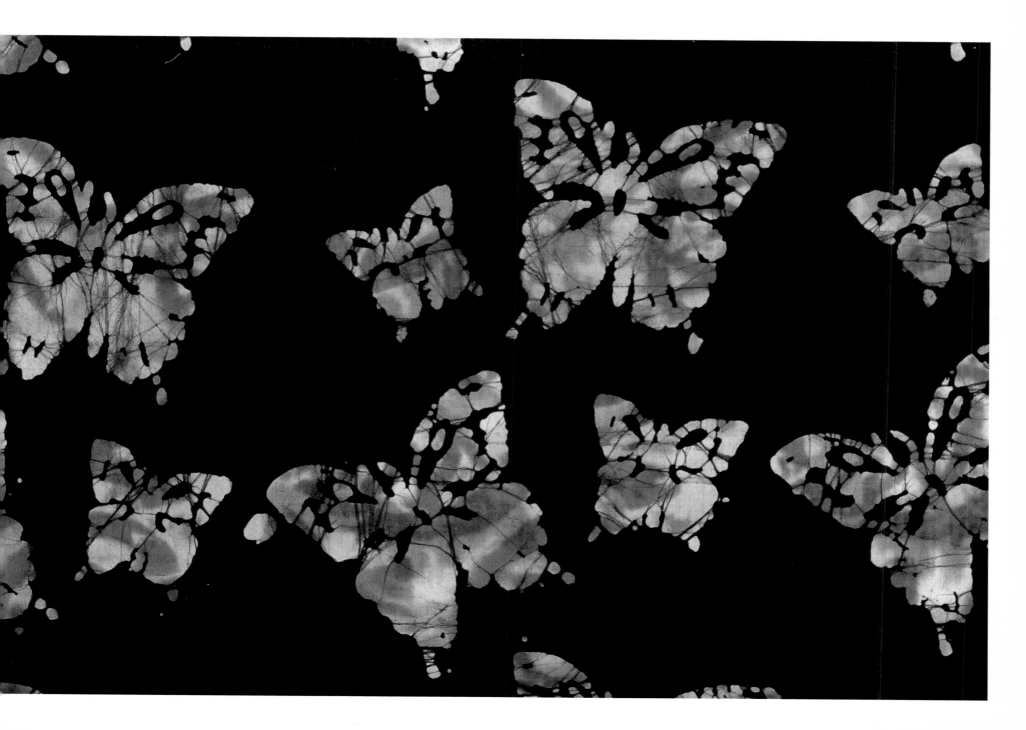

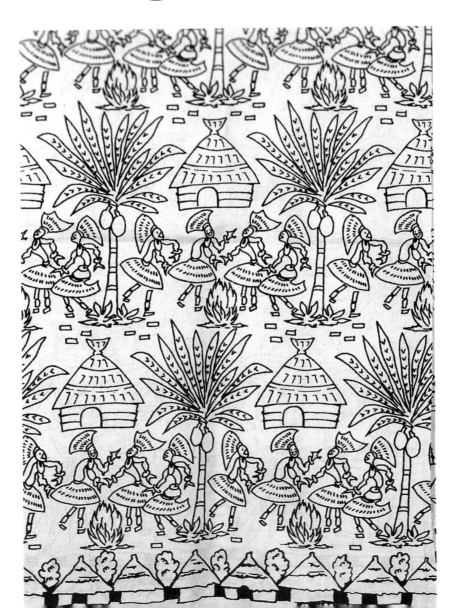

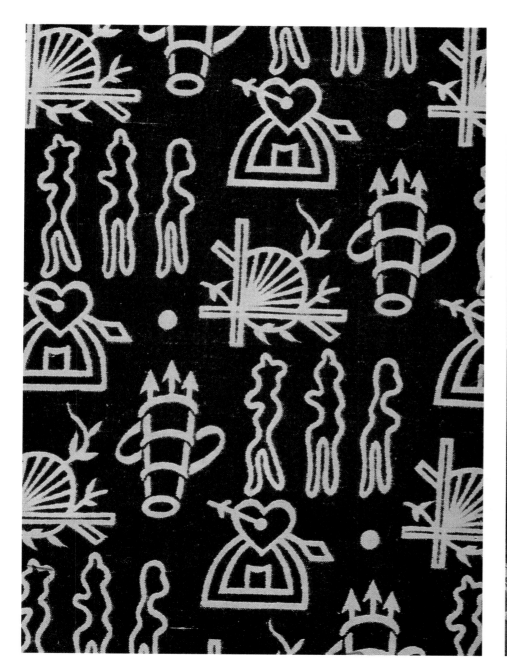

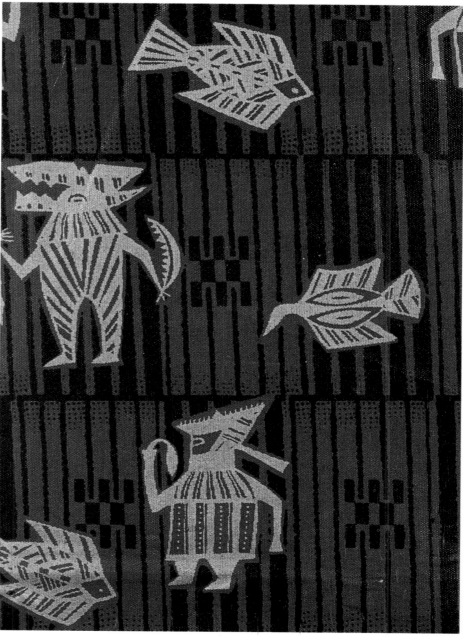

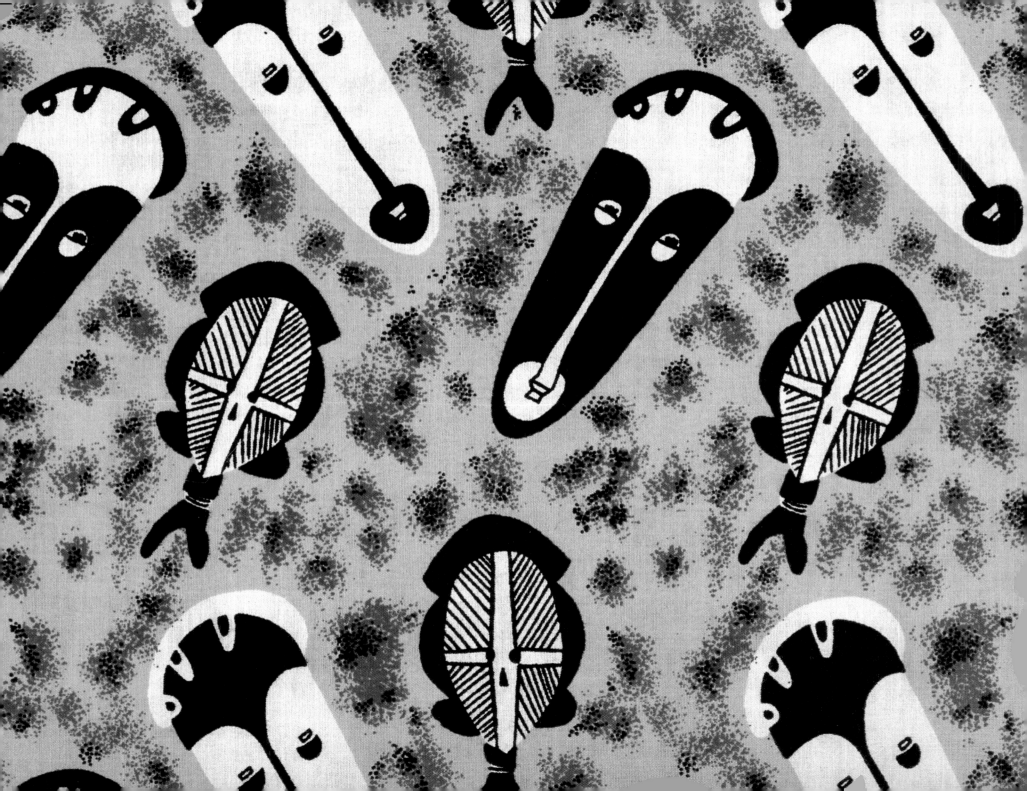

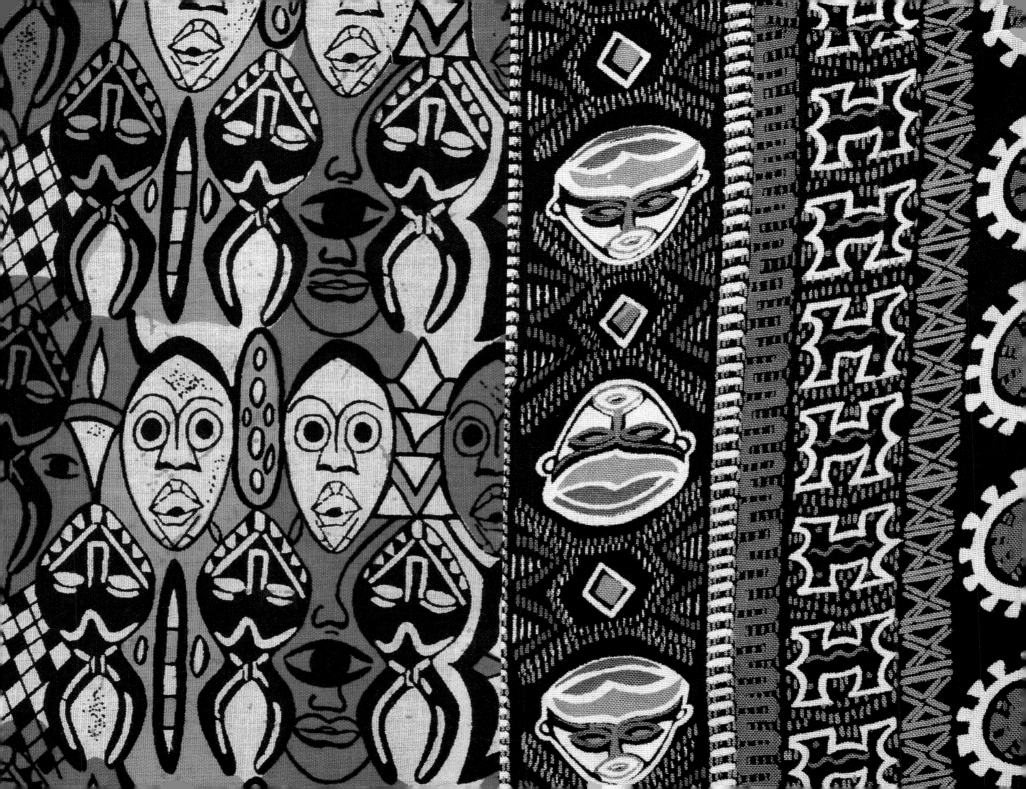

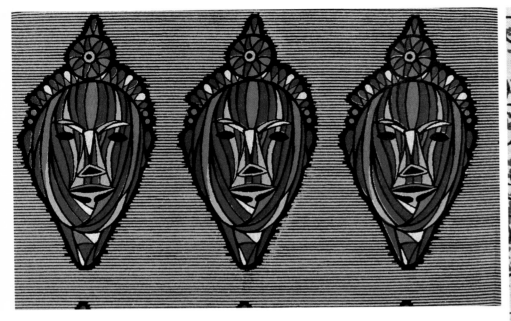

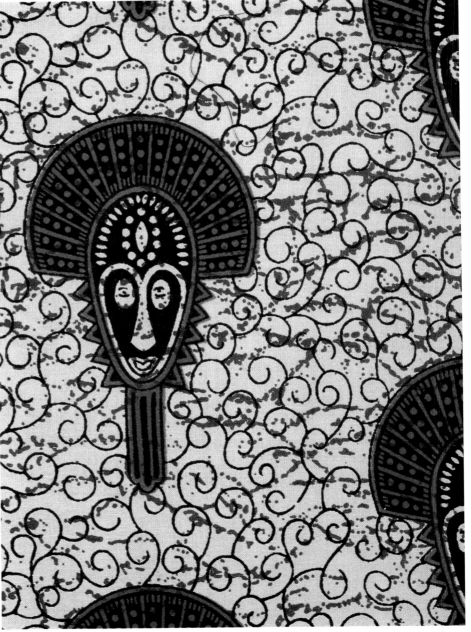

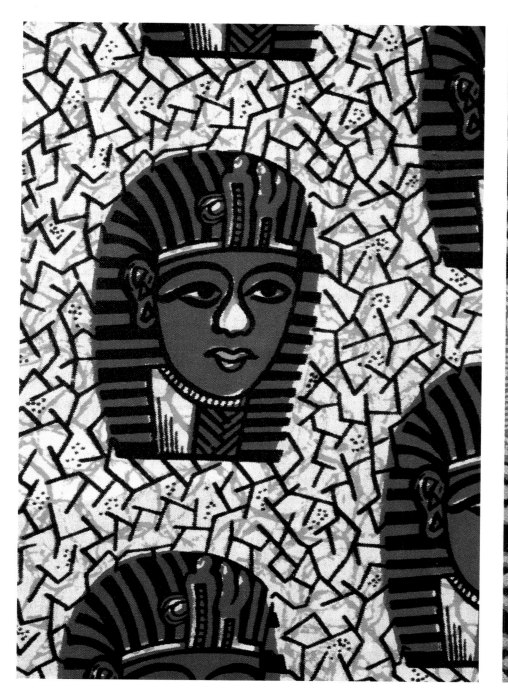
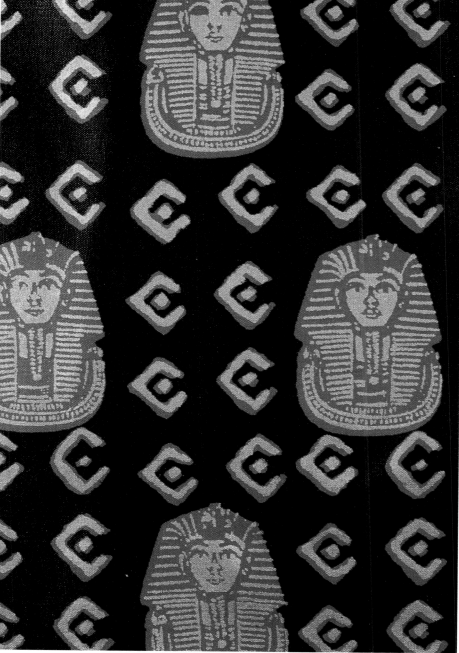

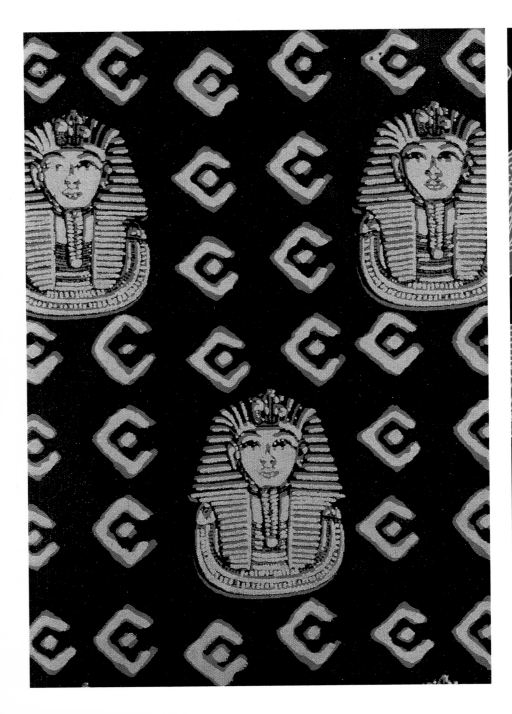

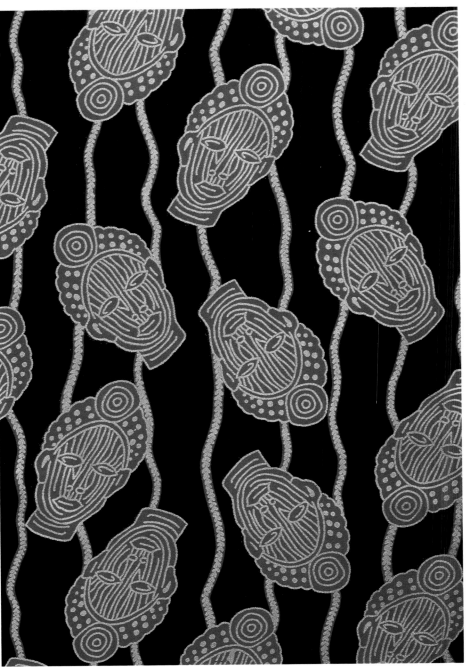

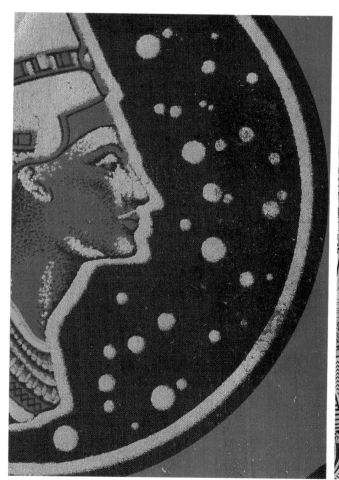

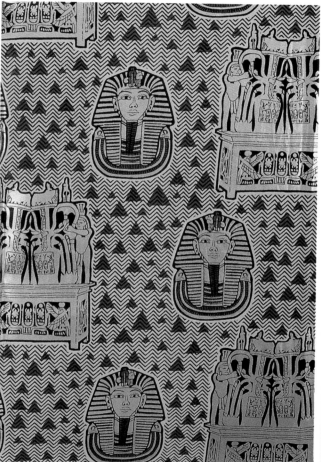

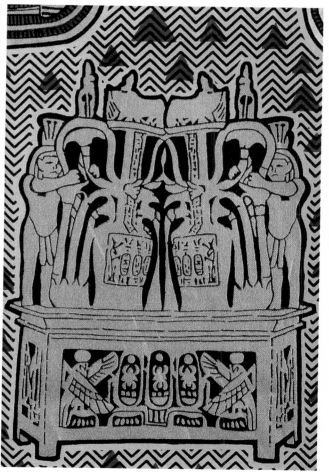

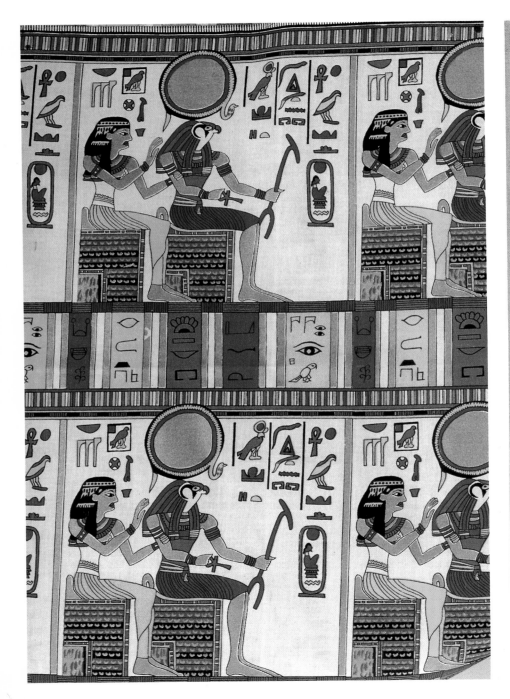
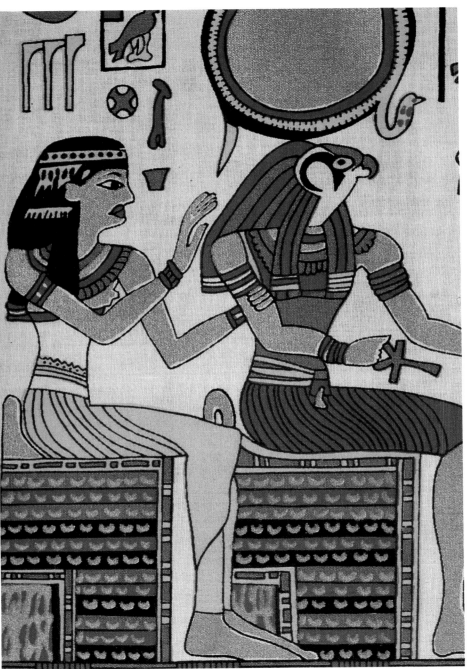

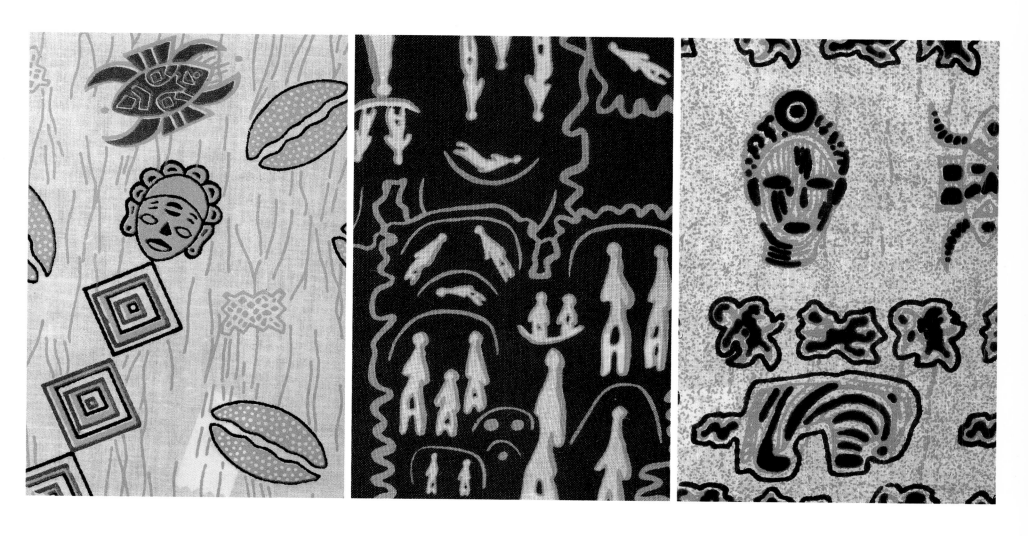

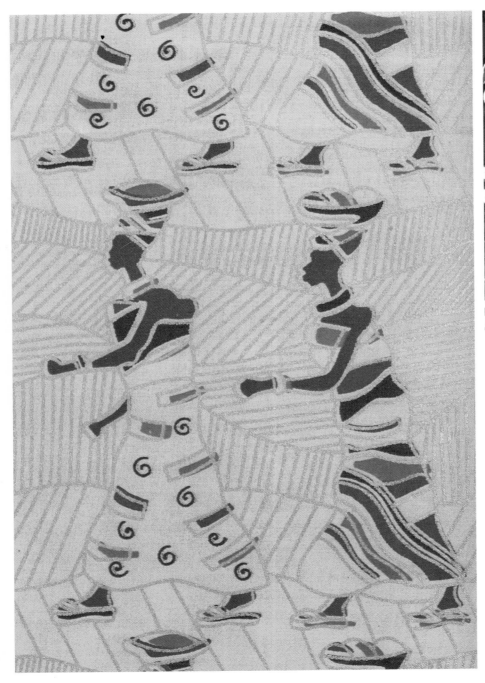

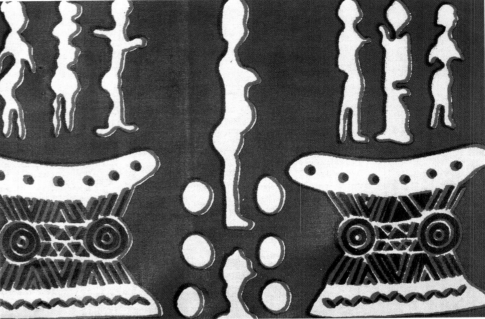

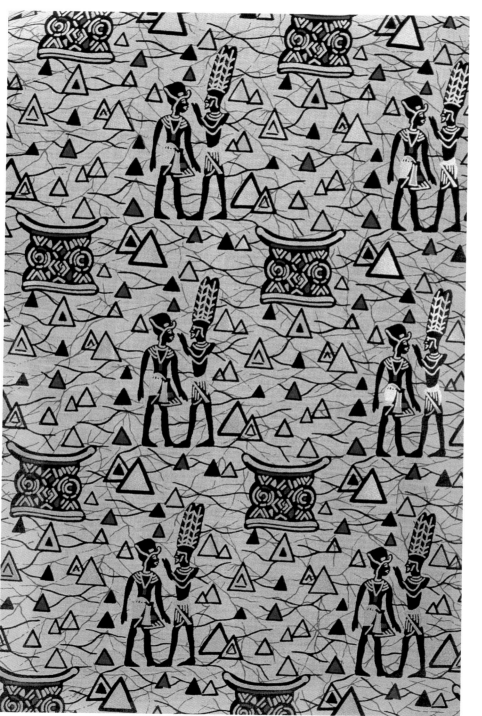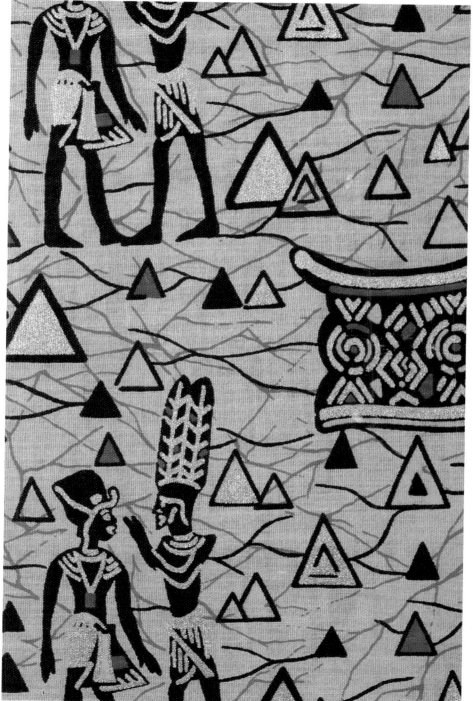

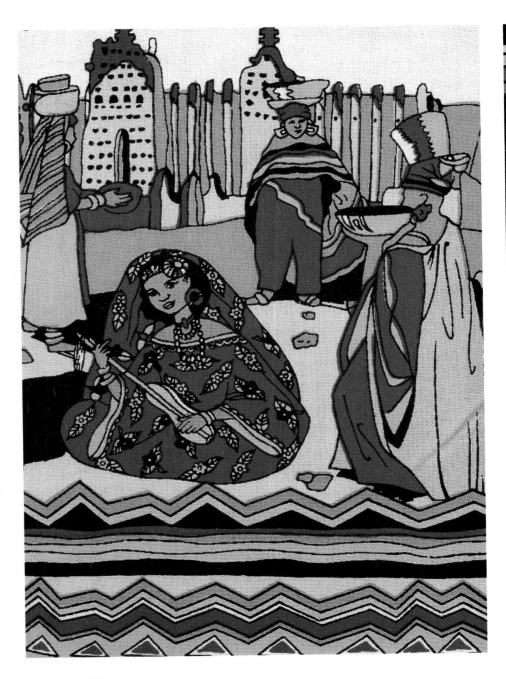

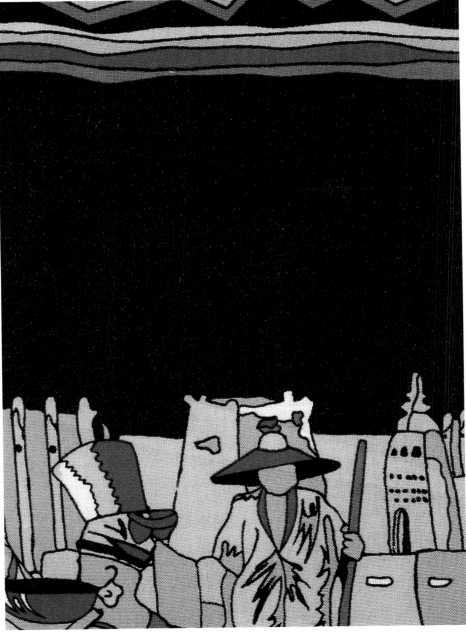

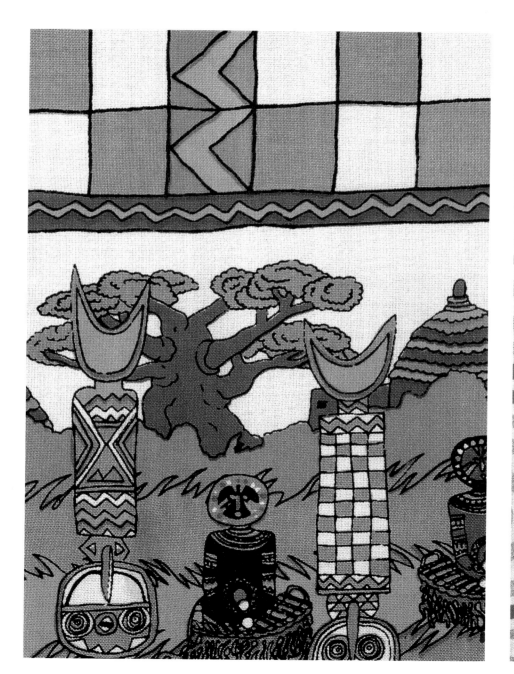

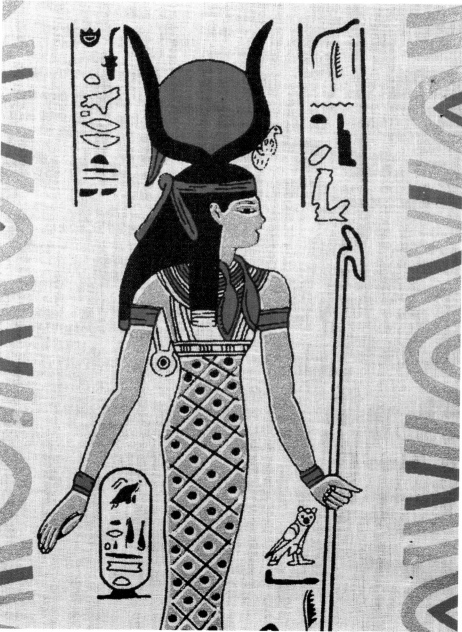

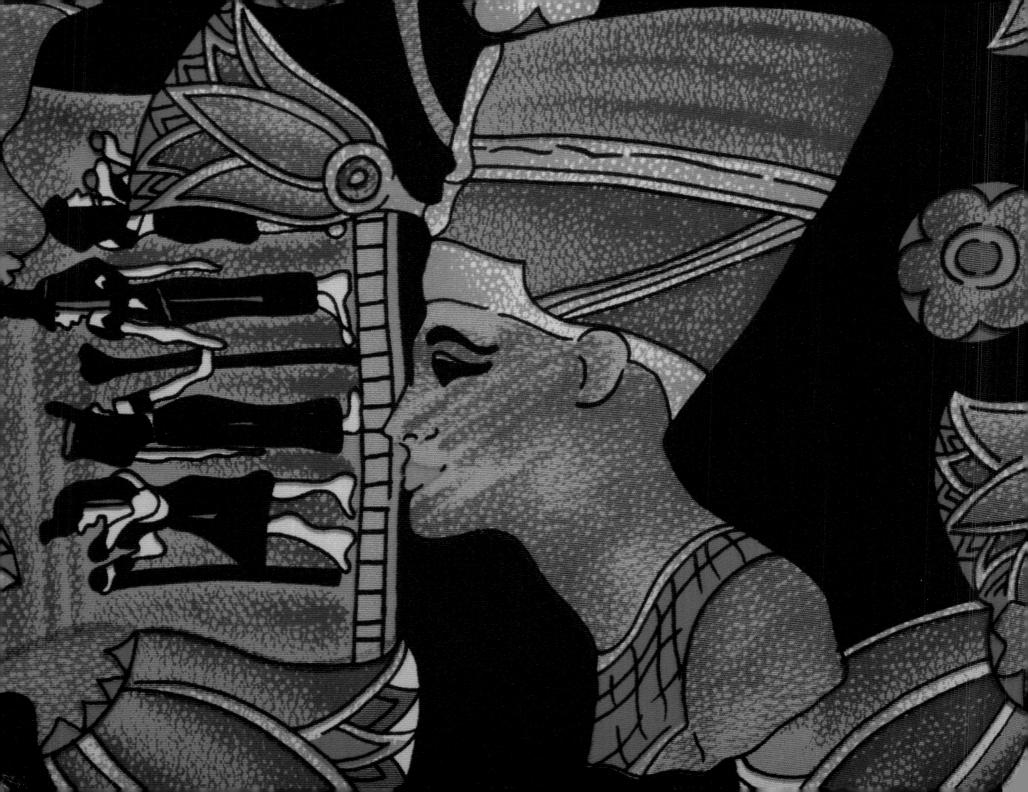

Glossary

Aso oke Weaving on a narrow-strip loom, especially by the Yoruba people of Nigeria as well as parts of Benin Republic and Togo.

Batik Dyeing method using wax as the resist agent; the pattern is covered with wax, the cloth is dyed, the wax is removed, leaving white areas that can be redyed for multi-colored designs; originally an Indonesian technique, now used around the world.

Bogolanfini Known commonly as "mud cloth," a painted hand-woven cloth, made in Mali. Dyes are made from mud and leaves to create traditional white patterns on black backgrounds.

Ikat Resist dyeing of yarns before weaving; the pattern is resist dyed on the warp and/or weft before dyeing. The cloth is characterized by a blurred or hazy effect.

Kente Royal cloth of the Ashanti people of Ghana whereby narrow strips are woven in complex geometric patterns; the strips are then arranged to form richer more complex designs. It was originally made from thread from unravelled European silk cloth. Recently, the Ewe people have also been weaving a similar cloth.

Raffia From younger leaves of several species of raffia palm of Madagascar and areas of Sub-Saharan Africa. The size of the finished cloth is determined by the length of the fiber used for the warp and weft. Made primarily by the Kuba people of Zaire, it has simple color combinations and geometric patterns and is sometimes embroidered, appliqued or used with cut pile.

Resist dyeing Method or device to protect parts of a cloth while allowing other parts to receive the dye. Batik, ikat, tie-dye, and wax-printing are popular resist methods used in Africa.

Roller printing Application of color to cloth surface using incised metal rollers; a much more commercial and economical method of creating the design than resist dying or weaving colored yarns.

Tie-dye Resist method in which areas of the cloth are tied in knots or with string, allowing the untied areas to receive the dye.

Wax-printing Developed by the Dutch to imitate batik, a dye resist material is used to create the design. Actually, a resin is used instead of wax; the resin cracks and causes fine lines of color to appear on the cloth. Wax-printed African designs are manufactured both in Europe for an African market and in Africa by local producers such as Afprint of Lagos, Akosombo Textiles of Ghana, and Sotiba of Senegal.

Selected Bibliography

Barbour, Jane & Doig Simmons eds. *Adire Cloth in Nigeria*. Ibadan, Nigeria: University of Ibadan, 1971.

Barnard, Nicholas. *Living with Decorative Textiles: Tribal Art from Africa, Asia and the Americas*. New York: Doubleday, 1989.

Clarke, Duncan. *The Art of African Textiles*. San Diego: Thunder Bay Press, 1997.

Kent, Kate P. *Introducing West African Cloth*. Denver: Denver Museum of Natural History, 1971.

Nordquist, Barbara et al. *Traditional Folk Textiles and Dress*. Dubuque, Iowa: Kendall/Hunt, 1986.

Picton, John & John Mack. *African Textiles* 2nd ed. London: British Museum, 1989 (U.S. edition New York: Harper & Row).

Plumer, Cheryl. *African Textiles: An Outline of Handcrafted Sub-Saharan Fabrics*. East Lansing: Michigan State University, 1970.

Polakoff, Claire. *African Textiles and Dyeing Techniques*. New York: Routledge & Kegan Paul, 1982.

Renne, Elisha P. *Cloth that Does Not Die*. Seattle: University of Washington Press, 1995.

Sieber, Roy. *African Textiles and Decorative Arts*. New York: Museum of Modern Art, 1972.

Spring, Christopher. *African Textiles*. New York: Crescent, 1989.

Spring, Christopher & Julie Hudson. *North African Textiles*. London: British Museum, 1995.